SIGNS
OF DISTINCTION

SIGNS
OF DISTINCTION

THE HISTORY OF NEW YORK STATE
AS TOLD BY 51 WELCOME SIGNS

CHUCK D'IMPERIO

**EXCELSIOR
EDITIONS**

Published by State University of New York Press, Albany

Excelsior Editions is an imprint of State University of New York Press

For information, contact State University of New York Press, Albany, NY
www.sunypress.edu

Library of Congress Cataloging-in-Publication Data

Names: D'Imperio, Chuck, author.
Title: Signs of distinction : the history of New York State as told by 51 welcome signs / Chuck D'Imperio.
Description: Albany : State University of New York Press, [2022] | Series: Excelsior editions | Includes index.
Identifiers: LCCN 2021061485 (print) | LCCN 2021061486 (ebook) | ISBN 9781438488912 (pbk. : alk paper) | ISBN 9781438488929 (ebook)
Subjects: LCSH: Village signs—New York (State) | New York (State)—History, Local.
Classification: LCC F119 .D56 2022 (print) | LCC F119 (ebook) | DDC 974.7—dc23/eng/20220126
LC record available at https://lccn.loc.gov/2021061485
LC ebook record available at https://lccn.loc.gov/2021061486

CONTENTS

FOREWORD

I have written nearly a dozen books about my native Upstate New York. Each book takes a look at a different aspect of the region. One book looked at the many famous (and infamous) people who are buried in Upstate (like Hollywood's first movie villain, and the first Black player in organized baseball, and no, it is not Jackie Robinson). Another explored the rich food history of the region (sponge candy, anyone?). Still another looks several of the famous homes across Upstate. And yet another examined the smaller, unknown museums of the region (like the Kazoo Museum!).

Having traveled, researched, and written so many books and articles about Upstate New York, I feel as if I have been everywhere. Of course, that is not true, but it feels like it. And one thing has always intrigued me in my travels.

The welcome signs.

I have given many talks all over the state about my books, and I always tell my crowds that if their town, no matter how big or small it is, has a story, then for goodness sake put it out there and let people know. So many places just ignore this one small opportunity to broadcast their history to those, like me, who are just passing through but who, if alerted, will no doubt stop and explore a little bit.

So, this book.

As I traveled around, I would come upon all of these great welcome signs that actually told a story of the place where it is located. And yes, I always stop. The stories are fascinating, and I felt it would make an interesting book to compile some of the best signs.

My only criterion was that the sign really did tell something about the town, some history, some DNA of the place. I was not looking for

platitudes or Hallmark-type slogans that were pretty and fanciful but really meant nothing.

Let me explain. Wouldn't you think, for example, that Corning, New York, might have an artistically beautiful sign at its entrance saying, "Welcome to Corning. The Glass Capital of the World." Or something similar. Well, I couldn't find it. They do have what looks like a state-issued sign with the name Corning on it but, well, in a word, boring.

Even the city that I lived and worked in for nearly forty years, Oneonta, missed the boat and therefore missed being in this book. Oneonta's moniker is "City of the Hills." Pretty, descriptive, "Hallmark-y." Everyone in the city loves that nickname passionately and has fought attempts to change it. Including me.

But I think a better sign might read, "Welcome to Oneonta, NY: Former Home of the World's Largest Railroad Roundhouse." Now, that would get me to stop and snoop around! "City of the Hills," yes, the mountains are beautiful. But, hey, all mountains are, aren't they?

In retirement, my wife and I moved twenty miles down the road from Oneonta to a little village called Unadilla. And, surprise. Unadilla gets it!

My heart smiled when we first crossed the bridge into the village and read the welcome sign: "Welcome to Unadilla, N.Y. Home of Boy Scout Troop #1." History right in the front window. I love that sign. It tells of an important component to the village's history (there even is a small Boy Scout museum on Main Street), and, well, it looks pretty darn nice on a welcome sign.

So, Unadilla made this book.

There are so many towns that took a swing when creating their welcome signs, but, frankly, whiffed. I will let others write about them. In these pages you will find "The Book Village of the Catskills," "Birthplace of Elsie the Cow," "The Arbor Day Village," "Home of the Pledge of Allegiance," "Trout Town U.S.A.," "Site of the World's Largest Living Sign," and New York's very own "Gaslight Village." All are fascinating stories, and all are right there to see on the welcome signs, you know, out there, by the edge of town.

If you have already bought my other Upstate New York books, then I am preaching to the choir. You love history and all of its little factoids. I mean, you are the type who will stop at the sign that reads, "Welcome to Gorham. Bandstand of the Finger Lakes," and ask a few questions. Aren't you? I thought so.

There are 51 chapters in this book. Not all signs are worthy of great, long sagas or histories to tell. But they all have something of interest to share with the passing journeyman. And there is one with which I would like to lead off this book.

The sign found in little Pratt's Hollow, New York, tells of what just might be the little map dot's only claim to fame. It is not much, really. Just a simple sign. It is posted on the exterior wall of the church at the four corners that, I think, constitute all of the hamlet of Pratt's Hollow.

I visited the location to take a photo for this book to illustrate what I was looking for, conceptually, for "Signs of Distinction." The sign, black letters on a white board, was way up over the backdoor entrance of the building. Very high up. An unusual spot for such a sign.

I walked over to a neighboring house and asked a kindly old gent who looked like he had lived in Pratt's Hollow all his long life why the sign was so high up on the building. His answer to me was, "Well, sir, I don't really reckon I know. But a lot of the signs before had been stolen, probably by college students down the road at Colgate University for their dorm rooms. It is a pretty odd sign. I'm not sure, but that might be the reason why they stuck the new one up so high. Out of reach, don't you know?"

I'll bet he is right. Because even if Pratt's Hollow appears to be just a quiet, four-country-road intersection tucked away in a corner of the town of Eaton in Madison County, it does have a great story to tell.

In the middle of the sign is an outline of New York State. The text reads: "Pratt's Hollow. The Geographical Center of NYS." Boom, that's the story!

Every place has a story to tell, and I hope that after reading this book some of the powers that be across the state will decide to put their fame and glory out on a welcome sign to let us all know what happened in their town or city.

I mean, let's face it, Pratt's Hollow had to do literally nothing to be declared the center of the state, except to, well, be there. And yet they put it up on their sign, and that got them into this book.

<div align="right">
Happy travels,

Chuck D'Imperio

Unadilla, New York

Facebook@A Taste of Upstate New York
</div>

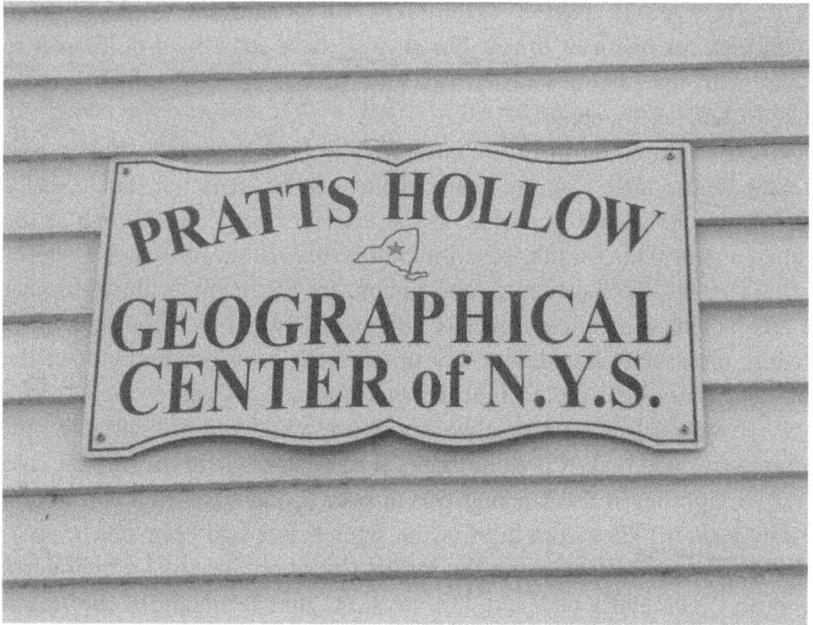

1

ADAMS, JEFFERSON COUNTY

"THE ARBOR DAY VILLAGE"

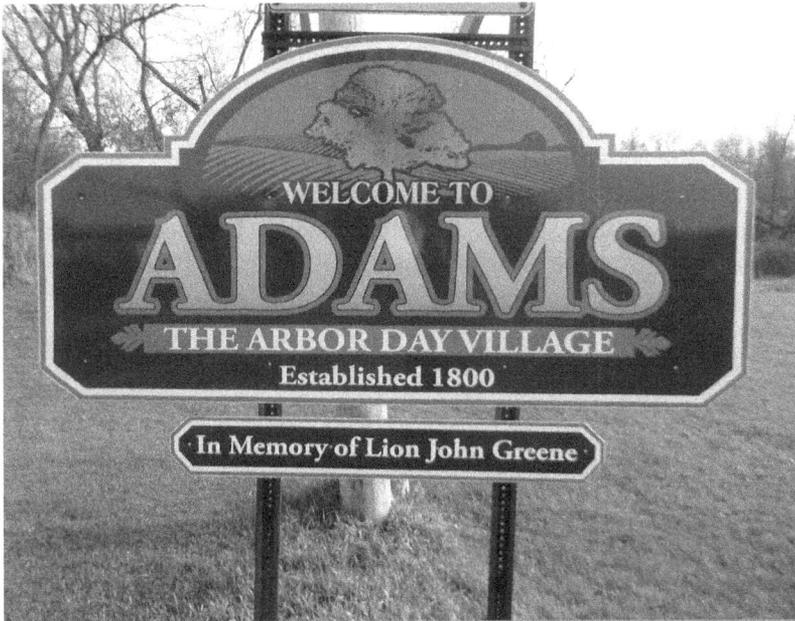

Probably the first time many of us remember celebrating Arbor Day was when we were little kids and we gathered in the back of our elementary schools to plant a tree. And then after that, nothing. For many years.

Today, Arbor Day is an important day to celebrate conservation, and its impact and importance have grown over the decades as we have become

more aware of how vital and precious our world and the environment are. It all started in little Adams, New York, with the birth of Julius Sterling Morton on April 22, 1832.

There is no question that Morton is the most famous person ever to be born in Adams, although it is doubtful he remembered anything about his birth village. Morton's parents moved the family to Michigan was he was just two years old.

He led an exciting, prosperous, and important life. He made a career in publishing, journalism, and politics. He served in several presidential administrations, with his career culminating in being named President Grover Cleveland's secretary of agriculture.

In this position he embraced his lifelong fascination with trees and agriculture and started a movement to plant millions of trees across the United States. He started by planting nearly 300 varieties of trees around his mansion in Nebraska City, Nebraska. The mansion is a replica of the White House and is today a National Historic Landmark.

Arbor Day was officially founded by Julius Sterling Morton in 1872 while he was a power in statewide politics. The "holiday" was soon adopted by the entire United States. On its first celebration, it is estimated that one million trees were planted across the country. Morton is honored throughout Nebraska with his name on schools, highways, parks, and office buildings. His son, Joy, went on to found the Morton Salt Company.

Today Arbor Day is celebrated on the last Friday of the month of April. It is acknowledged that at this printing the oldest living Arbor Day tree is a red oak planted near the public library in Chatham, New York. It was planted by schoolchildren in 1902 in honor of their favorite teacher, a Miss Harriet Seymour.

The history of Arbor Day: www.arborday.org

2

ANDES,
DELAWARE COUNTY

"LAND IN THE SKY"
"THE EPICENTER OF THE ANTI-RENT WAR"

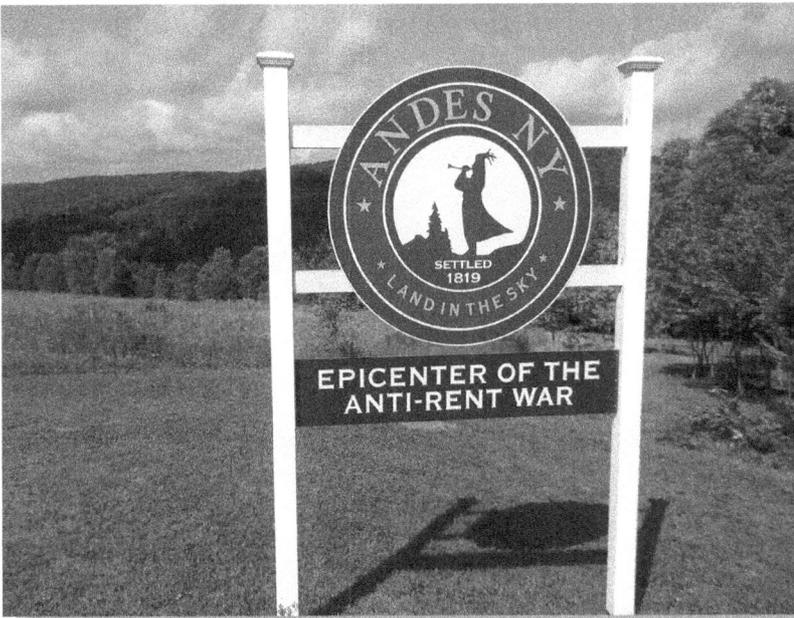

Andes is just within reach of the George Washington Bridge (three hours), which means that many New York City dwellers come up to the mountains on weekends and enjoy the charm of this quaint Catskills village.

There are two mottos on the welcome sign here. "The Land in the Sky" refers to the perch the village sits on in the Catskill range. With an elevation at more than 1,600 feet, the views coming in and out of Andes are spectacular. So much so that a pull-off viewing area has been created at the edge of town heading south on New York State Rt. 28. From here you can see varying shades of "purple mountains majesty," all lined up before you for miles in the distance. This chorus line of Catskill beauties incudes small hills, steep mountains, towering ski destinations, and pitched valleys. The sign at this pull-off features the image of a camera. And they are right. This is a great Upstate photo opportunity!

The Anti-Rent War was a nasty land dispute that took place between 1839 and 1845. The farmers had suffered long enough under the outdated rules of the manor system put in place by the mega-landowning patroons from a system begun a century before. The farmers rebelled against paying rent to absentee landlords and demanded full consideration for the land they toiled on. The "war" literally went from push to shove here in Andes on August 7, 1845.

After years of legal skirmishes and minor physical altercations across several Upstate counties, it all came to a head at Moses Earle's farm just outside the village.

Earle had accumulated a sum of back rent, and when the Delaware County sheriff came to collect it, Earle refused. It seems that he, and many of his neighbors, had had enough. After refusing to pay, the sheriff ordered that Earle's cattle be auctioned off to pay his tax debt. On the day of the auction, more than two hundred of Earle's friends and fellow farmers gathered en masse at his farm to protest the auction. Many of them were dressed in ragtag homemade Indian clothing and painted masks to hide their identities. They called themselves Calico Indians.

Undersheriff Osman Steele got the short straw that day. He went out to force the auction of the farmers' cattle. Tempers rose quickly under the noonday sun, words flew, and before anyone knew it, a shot ran out. Mortally wounded, Steele was carried into Moses Earle's farmhouse, where he soon died in the farmer's bed.

In effect, this violent insurgency ended the formal Anti-Rent War. But with that, the stories of what happened that day up on Dingle Hill continued to grow as the years went by.

It was said that Sheriff Steele stopped by a local bar in the village, the Hunting Tavern, to have a drink before he faced the angry mob on the hill. Apparently, the bartender warned him that violence was afoot if he went to the Earle farm. The legend is that upon hearing this, the ornery Steele downed a glass of whiskey in a single gulp and blustered, "Lead can't penetrate Steele!"

It was also reported that when Steele's dying body was taken into the Earle home, his last words were, 'Moses, if you only had a paid your rent there would've been none of this. I wouldn't have shot you." To which the farmer replied to the dying Steele, "If you had stayed home and minded your own business you wouldn't have been shot!"

The Hunting Tavern still stands on Main Street in Andes. And just a mile or so out of town, up on Dingle Hill, a historic marker tells the dramatic story of the face-off that took place on the very spot where a shot rang out, Undersheriff Osman Steele died, and a mob of Calico Indians helped cause the end of the Anti-Rent War.

The Hunting Tavern is now a museum. Known as the Andes Society for History and Culture, the museum has a great amount of local history and information pertaining to the Anti-Rent War. You can also see the fully restored tap room where Steele mistakenly thought "lead couldn't penetrate Steele."

Hunting Tavern Museum: www.andessociety.org

3

BAINBRIDGE, CHENANGO COUNTY

"HOME OF ELMER'S GLUE. STICK WITH US!"

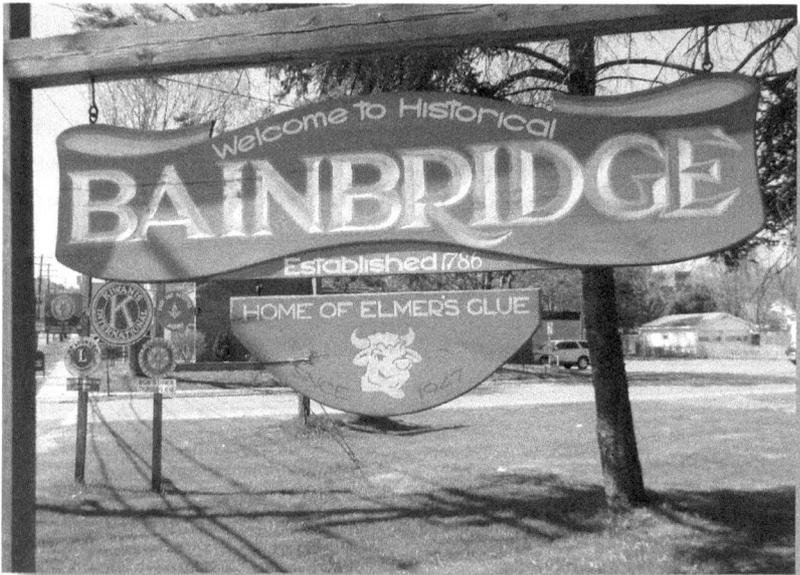

For a small village of fewer than 1,500 residents, this pretty little community on the Susquehanna River has a long and storied past. And it is all told in the small village museum on Main Street, which is open only a couple of days a month.

Inside the museum you will read about and see displays telling the story of native son Jedidiah Smith, an American explorer known as "The

Pathfinder to the Sierras." You will read about the formation of a Bainbridge company called American Plastics, which ended up giving America everything from construction hard hats to the ubiquitous Fisher Price "pop beads."

You will learn about politician Irving Ives, born in the village on January 24, 1896. He served as a United States New York senator from 1947 to 1959. He was also the co-sponsor of the first state civil rights law in the United States, which prohibited discrimination based on race. The village was once the home of America's first successful instant breakfast, Hansmanns Pancake Mix. Their motto was "just add water." Bainbridge has also hosted the longest single-day flat-water canoe race in the world, the seventy-mile-long General Clinton Canoe Regatta, since 1963.

All this and more, and it is all showcased in this tiny museum in the heart of the village.

Oh, and don't forget Elmer's Glue.

This iconic memory of our school days was born here in 1929. Borden's went on to become one of the area's largest employers. The Bainbridge Museum has a wide display of Borden's glue products from down through the ages on display, from the earliest beginnings to the last glue products, which rolled out of the Bainbridge factory before it closed in 2006. The factory started as the Casco company, which made a milk by-product that, it was discovered, could also help make glue in the same production process. Elmer the Bull was chosen as the mascot name for the glue product line because he was the "spouse" of the other famous Borden bovine, Elsie the Cow. Among the products on display at the museum are jars of Elmer's Safety Glue, made in Bainbridge.

Elmer's Glue was introduced to the nation in 1947 and was a big hit. Elmer's Safety School Glue was a godsend to parents and elementary school teachers alike. Before this, the temptation to taste the gooey glue was just too much for some children to resist. Borden's made a safety glue that was nontoxic and easy for children to use. It soon became a leader in the field. And who can forget those iconic glue bottles with the "tongue depressor stick" attached to the jar with a rubber band?

An interesting footnote is that Gail Borden, the millionaire inventor of condensed milk and the namesake of Borden's Glue, was born in Norwich, New York, which is just twenty miles north of Bainbridge.

Bainbridge Museum: https://www.facebook.com/BainbridgeNYHistorical Society/

4

BATAVIA, GENESEE COUNTY

"BIRTHPLACE OF WESTERN NEW YORK"

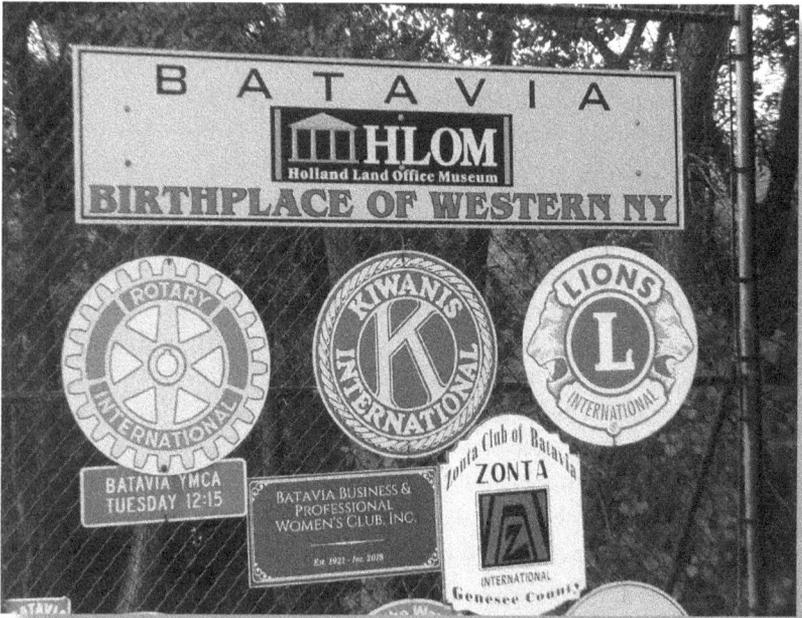

Batavia is a city of 15,000. Back at the dawn of New York State, this part of the region, what is now Genesee County, was about as far west as the frontier went. More than three million acres of land (the Holland Purchase) was sold to a group of Dutch bankers by owner Robert Morris on July 20,

1793. Morris, known as the "Financier of the Revolution," was an American Founding Father and a signer of the Declaration of Independence.

A land office was established in what is now Batavia with the purpose of carving up western New York into separate parcels that could be developed. Joseph Ellicott was hired to perform the largest land survey ever attempted. It took him more than two years to travel the area and document the land mass.

The Holland Land Company established an office in Batavia where most of the survey data and land distribution took place. This really was the opening of the door to western New York for development. Hence the "birthplace" mention on the city's welcome sign.

The Holland Land Office is today a fascinating museum in Batavia that helps visitors understand the magnitude, complexity, and importance of Ellicott's survey. The limestone building was designed by Ellicott and built in 1810. Initially the building was a busy place, with land seekers coming in and out in a steady stream asking about settlement possibilities in western New York. The building was declared a National Historic Landmark in 1960, the first such designation in western New York.

The phrase "doing land office business" refers to the activity around this important building in the early days of the region.

Ellicottville, New York, a Cattaraugus County village first settled in 1815, is named after the great surveyor.

Holland Land Office Museum: www.HollandLandOffice.com

5

BETHEL, SULLIVAN COUNTY

"HOME OF THE 1969 WOODSTOCK FESTIVAL"

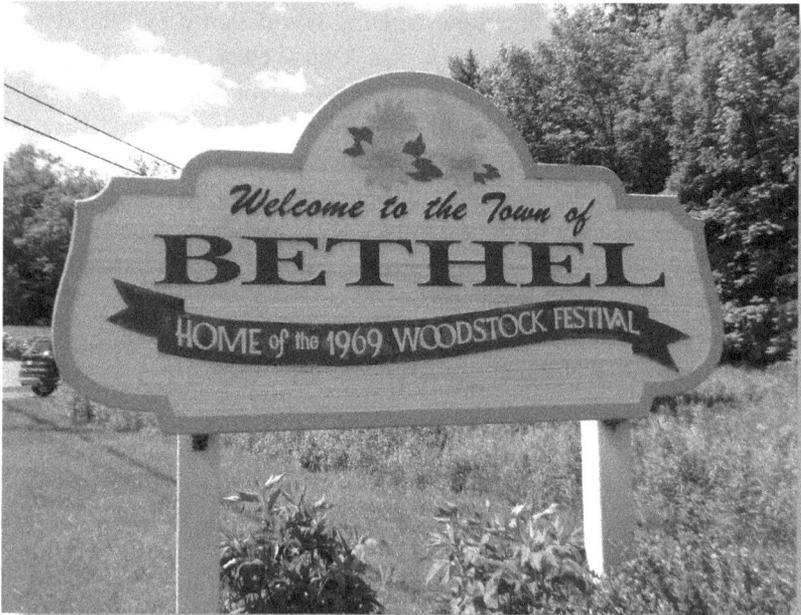

This is one of the most famous and popular destinations in the "Upstate" region.

What else can be said about the 1969 Woodstock rock festival? It is without a doubt the most documented music festival in history. We have seen the photos of the hundreds of thousands of young people converging

on a field in rural Sullivan County to enjoy a three-day rock extravaganza featuring the biggest stars of that era, including Janis Joplin, Jimi Hendrix, the Grateful Dead, and dozens more.

We have seen how this horde of young people endured torrential rains, limited food and water, and other uncomfortable living conditions on a hillside that quickly turned into a sea of mud. Books, television shows, documentaries, live recordings, movies, artwork, and other media documentation of the event were unparalleled.

But what about Woodstock today? Is there anything there?

The answer is yes. Today, the Woodstock Music Festival site is a required touchstone for those who were here, wished they were here, or imagined they were here. The hillside where hundreds of thousands sat waiting hour after hour for the concert acts to show is now a meticulously trimmed lawn of bright green grass. In one corner of the field, you can see where the actual stage for the show was erected. You can also see the iconic Woodstock logo monument located in a place that offers an unimpeded view of the landscape of the concert. This is a must for selfie lovers.

At the top of the hill is a new museum and performing arts center known as the Bethel Woods Center for the Arts and the Woodstock Museum. An extensive list of live entertainment brings concertgoers to this hallowed place all summer long. The museum documents the Woodstock experience in a variety of colorful and exciting multimedia exhibits and displays.

Although the area has pretty much returned to its sleepy pre-concert self these days, there still is much to see and learn. This is due to a relatively new Woodstock Heritage Trail. This ten-mile loop allows you to visit many of the sites of the 1969 era and learn what happened at these places. There are few buildings left standing from 1969, but there are some. A bar where concertgoers cooled off at, Hector's Inn ("Woodstock's Original Watering Hole"), is still open and thriving. A small general store, which was inundated with a hungry and thirsty army of young people, also is still open for business.

You can learn about Art Vassmer, the "peanut butter and jelly man," who sold hundreds of sandwiches to the horde; you can see an iconic "hippie VW bug" painted and sitting alongside Happy Avenue; and you can hold your phone up at numerous locations and view the QR code description of what happened here more than a half-century ago. Each of the nine designated stops on the trail includes color photograph displays.

Woodstock Heritage Trail: https://townofbethelny.us/bethel-heritage-trail

6

BROCKPORT, MONROE COUNTY

"THE VICTORIAN VILLAGE ON THE ERIE CANAL"

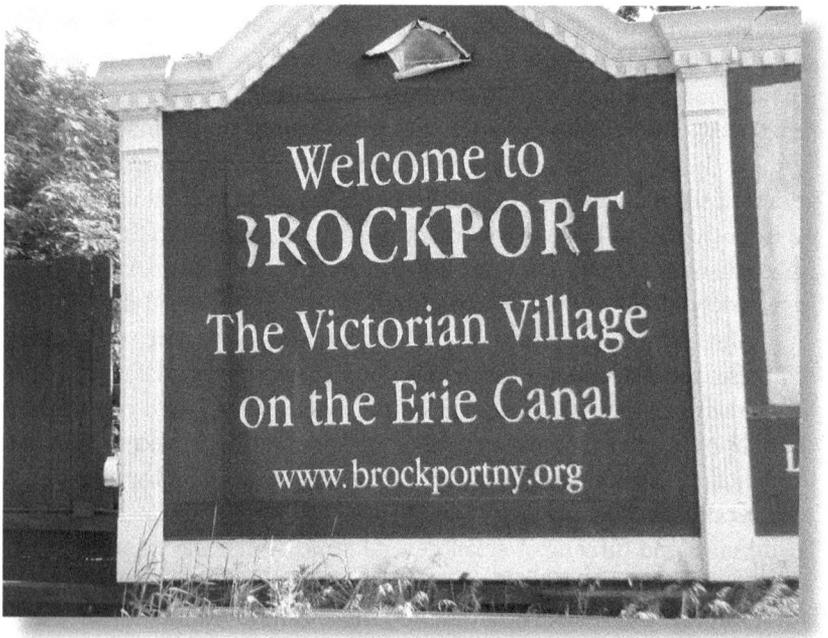

Brockport is a bustling community of about 8,300 residents. It has a rich heritage as being one of the major stops along the Erie Canal. Brockport, like so many other canal towns, pays tribute to its canal history with historical markers, murals, and festivals. In October 1825, the final leg

of the canal, from Brockport to Buffalo, was completed and the waterway was officially opened.

Brockport has an abundance of beautiful old Victorian-era homes. These harken back to the gilded age when men's fortunes were made (and lost) through ingenuity and hard work along the canal. Many of these homes are available to view in various walking tour formats.

The small downtown business district of the village also exudes historic and small-town charm. Check out the larger-than-life mural on the exterior of the Lift Bridge Book Shop. It is a colorful depiction of life in Brockport in the old canal days. A movie house, the Strand Theater, has been a family-friendly entertainment venue for more than one hundred years. And Barber's Grill and Tap Room has occupied a corner spot near the canal lift bridge and lock since 1929. They have been making a special sandwich here, the Balboa—sliced beef, mozzarella cheese, and garlic sauce served on toasted garlic bread—for decades. They offer more than a dozen different variations of this legendary sandwich. A Brockport Arts Festival attracts thousands to the downtown canal area each year.

Brockport is home to the State University of New York at Brockport. The number of students attending this university almost identically matches the population of the village, 8,300 each.

Brockport: https://www.brockportny.org/

7

CANISTEO, STEUBEN COUNTY

"SITE OF THE WORLD'S LARGEST LIVING SIGN"

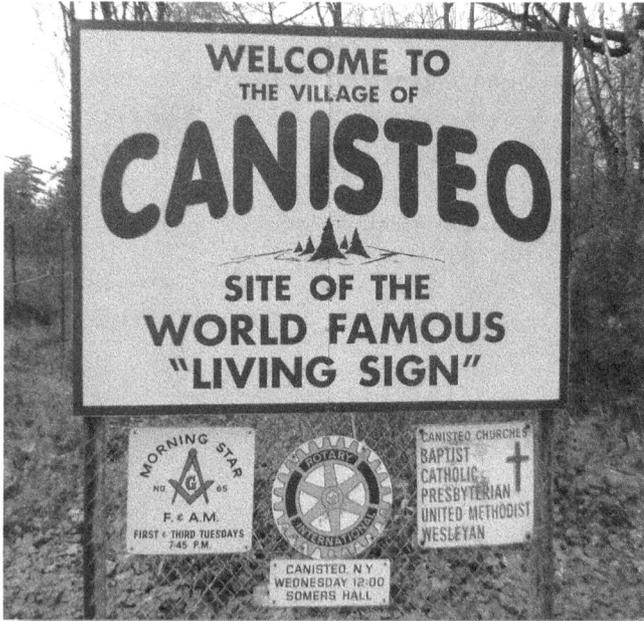

You see the welcome sign at the edge of town. And you wonder, "What the heck is a living sign?" Unless you know where you are going in Canisteo, you might have to wander a bit before you notice it. And then, unheralded and tucked on a hillside behind an elementary school, it looms into sight.

The Canisteo living sign began in 1934 when a group of Canisteo schoolchildren planted the seeds of 260 scotch pine trees all laid out to

(perhaps in the distant future) spell out the name of their village, Canisteo. The field in which the trees were planted measures 90 feet wide by 400 feet tall. Plenty of room for a forest of letters to grow.

Within a few short years, the words C-A-N-I-S-T-E-O could plainly be seen by passersby as well as by aircraft flying overhead. The sign became a bit of an attraction in this small community. People in neighboring towns came over to see the arbor alphabet laid out up and behind the school. Soon the world-famous "Titan of Trivia," Mr. Robert Ripley, came along.

At the time, Ripley was one of the most well-known columnists in the world for his uber-interesting "Ripley's Believe It or Not" feature stories. Ripley was duly impressed by the schoolchildren's work of outdoor art and promptly declared it "The World's Largest Living Sign." He put the living sign in one of his famous cartoon panels, which had a readership of nearly 100 million people, and the rest is history. The news of Canisteo's natural nameplate went viral, as they say.

Over the decades, the trees have had good years and bad years. At times they have flourished into full-blown letters, and at other times they have withered to a conglomeration of unrecognizable bare twigs. Still, the students and staff at Greenwood Elementary School have tended their iconic oddity with care and diligence.

Devastation struck in 2016 when a tree disease decimated the letters, and the trees had to be dug up. Answering pleas from sign-loving citizens, a new set of pine trees was placed in the same field as the old ones, and today the letters are clear as can be. Once again, the Canisteo "forest welcome mat" is ready to welcome visitors to town. The sign was placed on the National Register of Historic Places in 2004.

For many years, a "celebration" of sorts has taken place in Canisteo when large flocks of turkey vultures fly back to their roosting spots among the letters around St. Patrick's Day each year. Not quite as romantic as the proverbial swallows returning to Capistrano, but still a longtime tradition in this little village.

An interesting fact is that the living sign was planted exactly in a north-to-south direction on the hill behind the school. Because of this, the sign has been used as a navigational tool by area pilots flying in and out of the surrounding valley.

Living Sign: https://www.fingerlakeswinecountry.com/listings/canisteo-living-sign/2528/

8

CHAUMONT, JEFFERSON COUNTY

"HOME OF ONE OF THE LARGEST FRESHWATER BAYS IN THE WORLD"

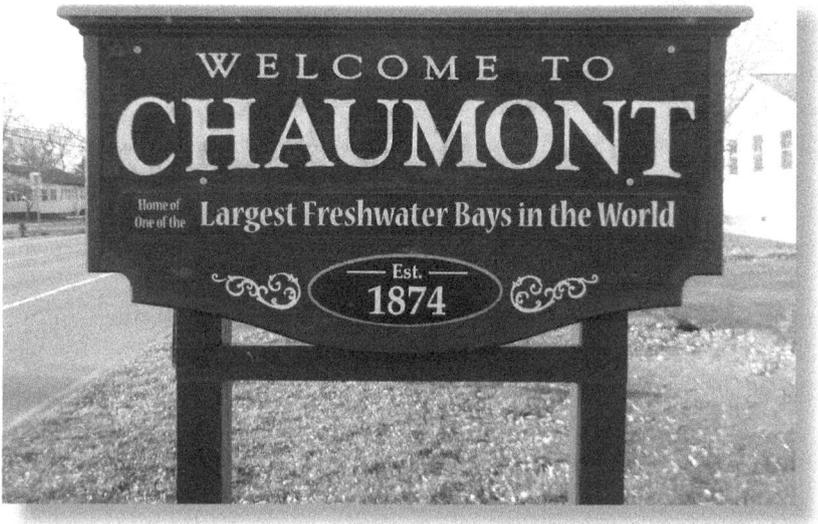

Tiny Chaumont, population just over 500, is one of those pretty little communities that dot the North Country. Places like Cape Vincent, or Clayton. They sit amid some of the most beautiful countryside in the state, usually adjacent to, or very nearby, either a river or a lake.

Chaumont sits on Chaumont Bay. The Chamber of Commerce calls this bay the "largest freshwater bay in the world," although the welcome

sign hedges its bet just a little bit by calling it "one of the largest." Perhaps this is because not every freshwater bay in the world has been found yet. ,

The bay is the home of some of the best freshwater fishing in the country. Not being a bit shy about the prowess of the fishing industry in Chaumont, the chamber states it is "a unique bay with Point Peninsula and Pillar Point providing the entrance, it has rocky shores, varying water depths, weed and rocky covered bottoms, and good shoals for spawning. Its murky depths provide some of the liveliest, mouthwatering pan-frying bass, pickerel, perch, pike, bullhead, lake trout and salmon." You could say that in Chaumont, it is usually fish for dinner!

Chaumont lies within the heart of the Golden Crescent. This is a coastal area that stretches from Sackets Harbor in the south to Cape Vincent in the north. On a map, this coastline will resemble a crescent that follows along the blue waters of Henderson Bay, Black River Bay, Guffin Bay, and Chaumont Bay, the largest.

There are many yacht clubs, fishing guides for hire, boat rentals, and marinas to handle the yearly crowd of anglers trying their luck "in the crescent."

All of these beautiful bays have, of course, the backdrop of Lake Ontario and then Canada beyond it.

Although very small, the village has an interesting history to it, as well as some pretty awesome buildings. Two to check out are the Hiram Copley Mansion and the Copley House. They were built of limestone native to the Chaumont area by the wealthy and influential father-and-son team of Alexander and Hiram Coley.

The Chaumont Historic District was placed on the National Register of Historic Places in 1990.

Chaumont: https://www.newyorkupstate.com/thousand-islands/2016/05/a_ day_in_chaumont_photo_essay_of_people_places_in_upstate_ny_village.html

9

CHERRY VALLEY, OTSEGO COUNTY

"MUSEUM. ALDEN MARKER, DUNLOP MARKER. FIRST PRESBYTERIAN CHURCH: FIRST ENGLISH SPEAKING CHURCH WEST OF THE HUDSON"

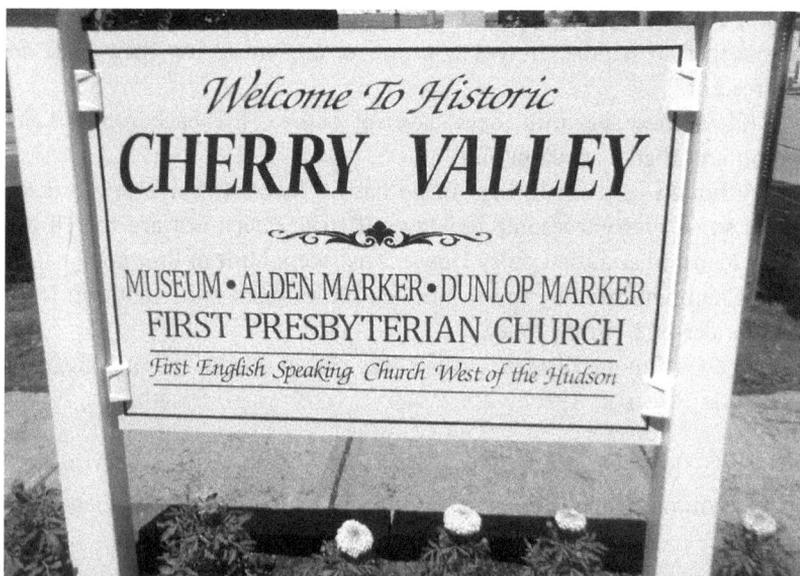

A beautiful and historic village of about 1,200 residents in the northern section of Otsego County. They really like to put it all out there for visitors, so let's take this sign one item at a time.

Museum. Any history of Cherry Valley must highlight the infamous Cherry Valley Massacre of November 11, 1788. British troops and their Native American allies raided this outpost (it had a small fort) and murdered more than fifty of its residents and defenders. Among the dead were both men and women, young and old. The savagery and violence that descended on the fort were shocking to almost everyone. Several died of tomahawk wounds and scalping.

Most of the defending regiment was stationed outside the fort during the attack at the home of the Wells family. The enemy battled their way into the home where they killed many soldiers and slaughtered the entire Wells family, numbering a dozen family members.

Seventy members of this small forest community were taken hostage and forced to take part in a "death march." The story of the massacre is told in great detail at the small, but very well done, Cherry Valley Museum located in the business district. There is an "electric map" that shows the topography of the village and fort on the day of the massacre and displays colored lights that move, representing the advancing raid.

One of the museum's most historic (and chilling) items is the Cole Bible. Resident Asa Cole was sitting in a chair reading the bible when the attack began. Attackers came into the home and killed him with a spear while he was still holding the bible. The bible is on exhibit here, and you can still see the blood stains on it from the mortal wound received by its owner.

Alden Marker: Located just outside the village proper, this marker denotes the place where Col. Ichabod Alden, who was the commander of the outpost, was killed by a thrown tomahawk.

Dunlop Marker: Denotes the spot where the Dunlop family had their homestead and where they were killed during the massacre.

First Presbyterian Church: First English-Speaking Church West of the Hudson: The church was founded in 1741 by the Rev. Samuel Dunlop. The current church is the fifth one built on this site and was dedicated in 1873.

Cherry Valley is very small, but kudos must be given to the historical society here. It is very easy to stroll the little streets of the town, admiring the beautiful homes, gardens, and lawns in the neighborhoods, all the while being surprised by a historical marker that will pop up and describe the happenings of the past.

The old Cherry Valley cemetery has a massacre memorial in it as well as the graves of several Revolutionary War officers, three US congressmen, a famous actor, a famous writer, and several other noted graves.

Cherry Valley Museum: https://cherryvalleymuseum.com/

10

CHITTENANGO
MADISON COUNTY

"BIRTHPLACE OF L. FRANK BAUM,
AUTHOR OF THE WONDERFUL WIZARD OF OZ"

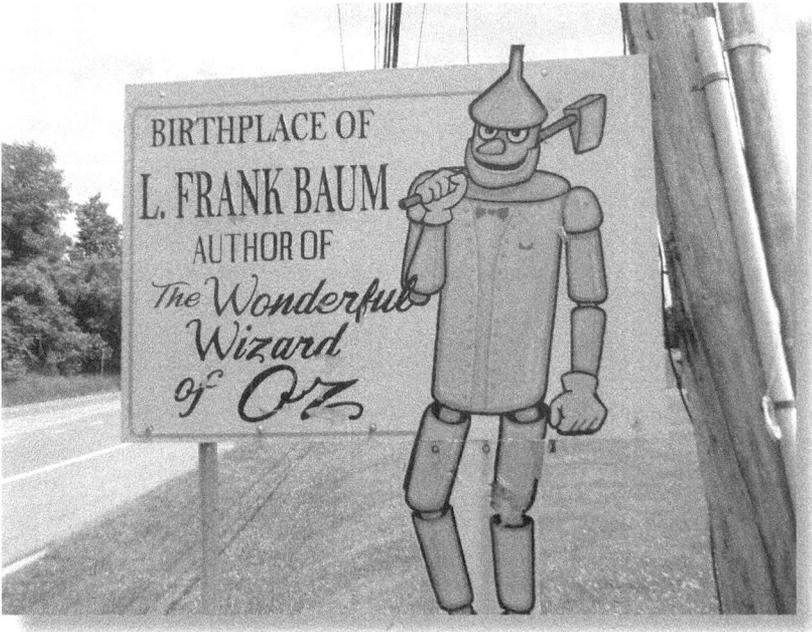

L. Frank Baum is the author of one of America's most beloved books, which gave us one of America's most beloved movies. His birthplace is a small town of fewer than 5,000 residents east of Syracuse. On most days it is a sleepy community; perhaps most people work to the west in the "Salt City."

When visitors arrive looking for an Oz-tastic experience, they will find little to revel in. A few shops, some empty storefronts, a Wizard of Oz Museum that is open irregularly, and a couple of places to eat. That is not to say there is nothing to revel in, though. Just look at the sidewalks, for example. Yes, you guessed it. They replicate the famous yellow brick road from the book and movie. There is also a lovely public plaza in the center of town, which boasts a two-story-tall colorful mural depicting the history of the village.

At the southern entrance to Chittenango you will find one of central New York's most famous and popular waterfalls. Thousands come here every year to Chittenango Falls State Park to marvel at the 187-foot waterfall and to hike the park.

But other than that, there is little else to remind you that L. Frank Baum was born here. It was even hard to find a sign for this book, which I was sure would have Baum or Oz on it. No such luck. After walking around the business district for some time looking for such sign, I went into a store and asked about it.

"Hmmm, let's see," said the clerk. "I think there is a sign somewhere that mentions L. Frank Baum." She asked a customer for help. The reply was, "Yes, it is way out on the highway by the casino."

So out to the casino I went, and sure enough I found the sign pictured above. The casino, by the way, is called the Yellow Brick Road Casino. It opened in June 2015. The casino displays the Oz concept in several varying ways: from the "tornado" art installation in the center of the casino floor, to flying monkeys appearing randomly throughout, and to eating places like Wicked Good Pizza and the Heart and Courage Saloon, the "Baum connection" is unmistakable.

And let's face it. You have to like a slot machine that plays a video of the Munchkins singing "Follow the Yellow Brick Road" when you hit free spins.

The village pays tribute to its famous native son with an annual Oz festival that attracts thousands to the village, many of them dressed up as their favorite characters from the immortal book and movie.

Wizard of Oz festival: http://www.oz-stravaganza.com/

11

CONESUS, LIVINGSTON COUNTY

"HOME OF THE TURTLESTONES"

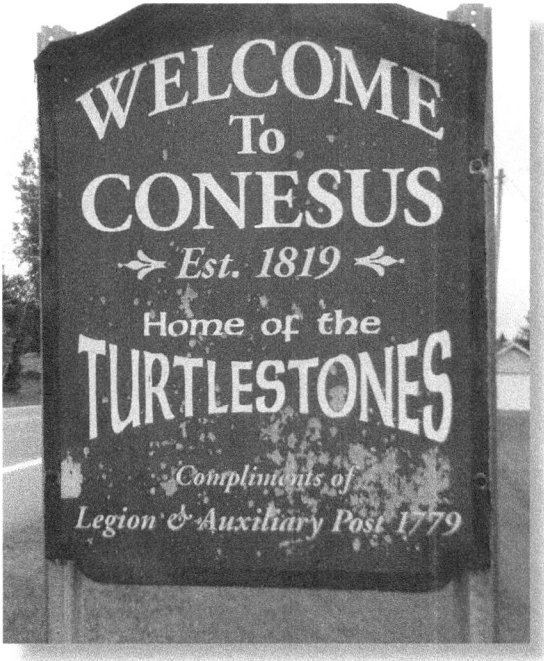

What the heck is a turtle stone? (It is spelled as both one word and two). Seeing the sign made me, like so many others, I am sure, pull over and start to ask some questions.

Apparently a turtle stone is a large round, gray stone that has solidified into basically concrete over the centuries. Found here along the Conesus

Lake area, the stones (geologically known as "concretions") do look like turtle shells, as the water rivulets from the hillside creeks have trickled over these stones for millennia, causing dark gray lines, or division markings, to be found in the rock. They are rare but can still be found. Locals have used the turtle stones to line garden beds and pathways.

After leaving Conesus, a village of 2,500, I had to look these oddities up. Images will show you that the turtle stones clearly resemble the human brain. They are not very pretty, actually, but odd enough to make them a keepsake if found. Turtle stones have been found all over the world where the Ice Age conditions are right, such as the Arctic, Siberia, Iceland, and other cold spots. It is interesting that even in these remote locations the rocks are referred to as Conesus Turtle Stones, because they were first named when found in the Finger Lakes region many decades ago.

The village must love these turtle-shell looking stones because it highlights them on its "welcome" sign. And this also got me thinking: I wonder what the Conesus school sports mascot is? Could it be, should it be, a costumed turtle stone?

Unfortunately, no. Conesus kids go to a larger school district just seven miles away in Livonia, New York. No turtles there. That is Bulldog Country!

12

COOPERSTOWN, OTSEGO COUNTY

"HOME OF BASEBALL; VILLAGE OF MUSEUMS"

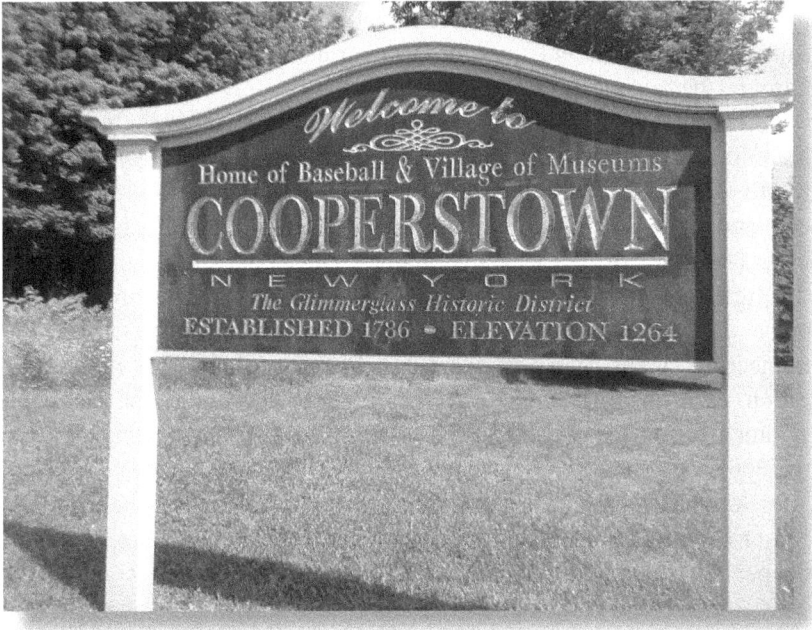

This is one of Upstate's most popular destinations. Although the "home of baseball" idea has long been debunked, the storied history of America's pastime lives on in the one-stoplight village of fewer than 2,000 residents.

The National Baseball Hall of Fame and Museum sees tens of thousands of visitors each year to its Main Street location. Nothing short of a

shrine to the sport and its heroes, the museum is alive with memories; the displays and exhibits are fascinating; the artifacts here cover almost every major baseball event over the last hundred years; and the Hall of Plaques, where the true greats of the game are honored, is a place of hushed reverence and whispered memories.

Doubleday Field, one of the most historic baseball stadiums in the country, is also located on Main Street. Dozens of shops sell team memorabilia, bats, jerseys, pennant, books, and more.

The Farmers Museum on the west side of Lake Otsego is a must-see. It essays life in a small town evoking nineteenth-century traditions and experiences. There are many craftsmen in action, including a printer in a working print shop, blacksmith, broom maker, and so forth. Of special note, the Cardiff Giant, the onetime "greatest hoax ever put upon the American public," rests eternally here. The ten-foot-long man made of stone is the superstar of the Farmers Museum. Also, a ride on the magnificent Empire Carousel here is always a treat for all ages.

The Fenimore Art Museum, literally across the street from the Farmers Museum, is a small but elegant art museum with ever-changing exhibits (Keith Haring, Georgia O'Keefe, Ansel Adams, Andy Warhol, Frida Kahlo, etc.) and offers up a heavy dose of wonderful Hudson River School pieces.

The Glimmerglass Opera is located farther up the lake and is one of the great rural opera houses in the United States. Its architecture reminds one of a hop barn, paying tribute to the hops industry, which once was the number-one industry in Otsego County. The opera house has no amplification, as it has perfect acoustics. Before and after a performance in the summer, the side walls quietly slide open to let the lake breeze waft over the 900 seats.

All of this, and so much more, can be found ringing the southern end of Lake Otsego, a pristine sparkling lake that writer James Fenimore Cooper referred to in his novels as "Glimmerglass."

A great New York, and a great American, village.

www.thisiscooperstown.com

13

CUBA,
ALLEGANY COUNTY

"FIRST OIL DISCOVERED IN AMERICA 1627"

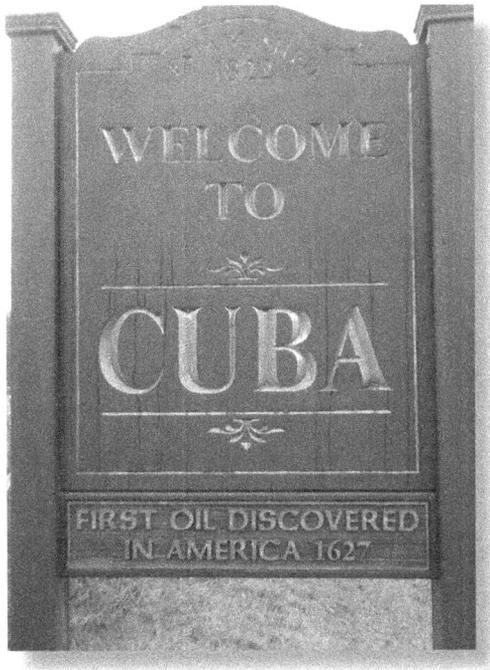

It is "Final Jeopardy!" time, and you are feeling confident. The question is revealed. "Where was the first oil well in America discovered?" A bead of sweat rolls down your forehead. A thousand old movies about oil wells, wildcatters, and "black gold" flip through your mind. Should I say Oklahoma City? Tulsa? Houston? Yeah, that's it. I'll go with Houston.

Waah, waah, waah. The answer is Cuba, New York.

Huh?

Just outside the village is an overgrown roadside pull-off. A weather-worn monument identifies it as the site of the Seneca Oil Springs. You walk a couple of hundred feet into the woods and park in a gravel parking lot. In front of you is a, well, I don't know what it is. A completely overgrown "pool" of some sort surrounded by a wrought-iron fence. Frankly, it looks like a swamp, and a dangerous one at that. Not very big, but for obvious reasons somebody does not want you to get too close.

That's it. Just a swampy little pool filled with something. No gushing oil towers, no grizzled wildcatters running around yelling, "It's oil, I tell ya!" Just a small, swampy pool. But the first of everything is historic, and this place is no different.

This is where in 1627 a Franciscan missionary named Joseph de La Roche Daillon stumbled upon the first petroleum site in what later would become America.

A perfect *Jeopardy!* question, indeed.

Cuba (not named for the country) has an abundance of history attached to it. At one time it was known as "The Cheese Capital of the World." The story is told that 150 years ago the great cheese barons of the region would meet at the Kinney Hotel bar in Cuba each week. They would do their tabulations of the current cheese situation, settle on a figure, down a shot of whiskey, and go out on the front porch to announce the new going price of cheese to waiting reporters and the world.

Today one of the busiest places in town is the Cuba Cheese Shoppe, which welcomes thousands of visitors each year to one of the largest cheese stores in western New York.

Cuba Lake, built as a water-regulating reservoir in 1852, was at the time the largest manmade lake in New York State. Today the 500-acre lake is used for recreational activity.

McKinney Stables is just a mile south of the village. It was built by William Simpson, a multimillionaire pawnshop owner. It was meant to hold his priceless racing horses. Built to be fireproof, when it was finished in 1909 it was the largest concrete building in the world. It is quite a sight to see.

Visiting the location of America's first oil well is probably only for the most die-hard road warriors. It is neat, in a trivia kind of way, but really there is not much to see.

But, wait. You can visit the Seneca Nation Oil Springs Casino, which is adjacent to the historic well site. You can't miss it. The last time I was there, it featured a large sign out front that read "Strike It Rich Here!"

Next to an oil well. I get it.

DANSVILLE, LIVINGSTON COUNTY

"HOME OF CLARA BARTON CHAPTER #1 AMERICAN RED CROSS HOME OF NEW YORK STATE BALLOON FESTIVAL"

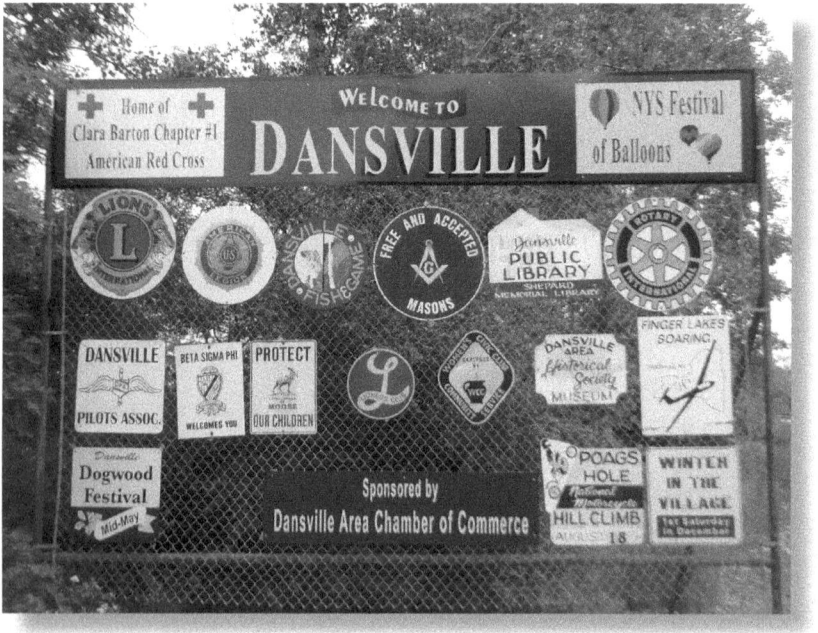

Clara Barton is without a doubt one of the most famous American women of the nineteenth century. As founder of the American Red Cross, her prestige and reputation were global.

Barton was a battlefield nurse during the Civil War. She and her nurses never shied away from the most dangerous of battles. As she traveled from battle to battle, she carried with her a portable desk, which she used each night to record and document her day's activities, the injuries she faced with the soldiers, and her thoughts on the effects of war. After the war, she visited western New York to give a lecture and recuperate from her war-weary experiences at the famous "Our Home on the Hillside" sanitorium here. She fell in love with the area. She later returned to Dansville, where she lived from 1876 to 1886,

It was from her Dansville home that "The Angel of the Battlefield" began to organize a national organization, the Red Cross, and attempt to get the organization sanctioned and supported by the United States government.

She established the first Red Cross office at 57 Elizabeth Street in Dansville on August 22, 1881. Today it is a museum to Barton, the Red Cross, and the Civil War era.

The New York State Festival of Balloons has been held in Dansville for more than forty years. The sky is filled with giant, colorful hot air balloons both for sunrise liftoff and for evening glow flights. Balloon rides are very popular.

The festival, which is held at the Dansville Municipal Airport, draws more than 30,000 visitors to this small village of about 4,500 residents each Labor Day weekend.

When in Dansville, be sure to visit the Star Theatre on Main Street. This movie house is one of Upstate's oldest (it opened in 1921) and started by showing silent movies and hosting vaudeville acts. Its Art Deco over-hanging marquee is one of the village's landmarks.

Clara Barton Red Cross Museum: http://www.dansvillechamber.com/index. php/business-members/clara-barton-chapter-1-american-red-cross/
New York State Festival of Balloons: https://nysfob.com/
Star Theatre: https://www.startheatredansville.com/

15

EAST BLOOMFIELD, ONTARIO COUNTY

"HOME OF THE NORTHERN SPY APPLE"

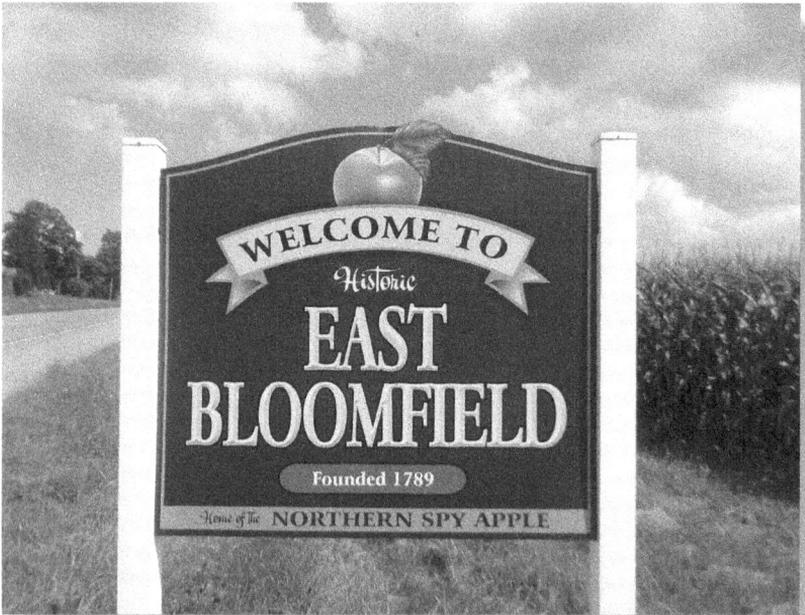

This is a beautiful painted welcome sign featuring a luscious red Northern Spy apple.

This apple is one of America's favorites. It is popular to pie bakers, cider makers, and those who want a juicy, healthy treat packed into their lunch boxes.

Nobody knows how it got its name. Some speculate that as the apple grew in favor in the 1800s, it was named after a popular abolitionist (although the person remained anonymous) who wrote a series of books about the Underground Railroad titled *The Northern Spy*. No connection between the book and the apple has ever really been proven.

The first seed for the apple was planted by Herman Chapin in 1800 at his farm in East Bloomfield. The original twigs were eaten by rabbits, but the plant's roots were replanted, and the first apple tree reach its fruit-bearing year between 1825 and 1830. Soon, hundreds of trees sprouted up in this Finger Lakes region, and an apple legend was born.

Today, there is even a bronze plaque on a monument in a field where that very first fruitful fruit tree was planted. Located off Boughton Road, it reads: "The original Northern Spy apple tree stood about 14 rods south of this spot in a seedling orchard. Planted by Heman Chapin about 1800. The early Joe and Melon apples also originated in this orchard." The plaque was erected by the Ontario Fruit Growers County Association a century ago.

It should be noted that the original "father" of the Northern Spy apple is shown in many references to be Herman Chapin. However, the monument attributes the person to be Heman Chapin. Misspelling or not, we thought we might preempt a reader's question.

New York State ranks second behind only the state of Washington in apple production.

History of Northern Spy Apples: www.outonalimbapples.com

16

EAST DURHAM, GREENE COUNTY

"EMERALD ISLE OF THE CATSKILLS"

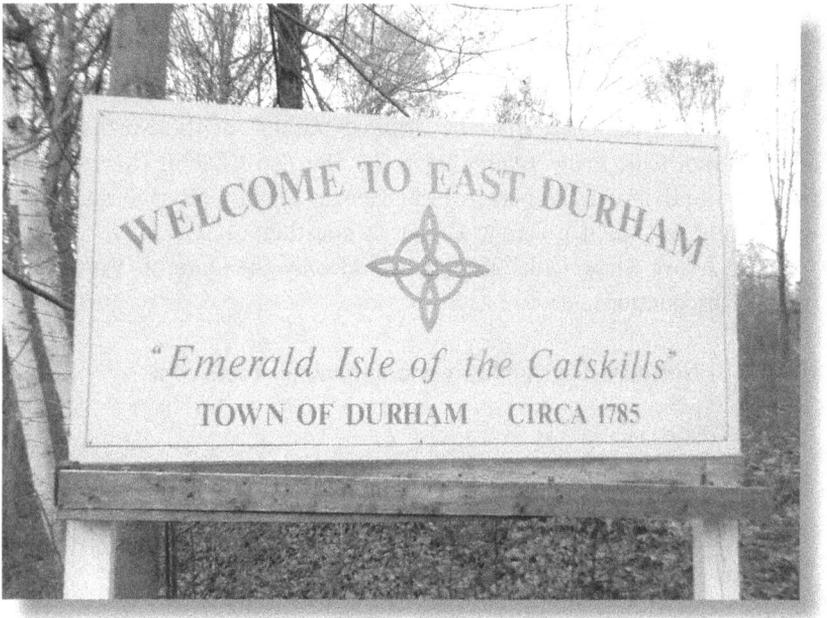

There is so much evidence of that magical phrase "the melting pot" in Upstate New York. We know about the storied migrations to New York City, which has made it perhaps the ultimate melting pot of the world. But Upstate has its little pockets of international history too.

Ever wonder why so many people of Scandinavian descent ended up in the Jamestown, New York, area? Or Poles in Utica? And what about all

of these Jewish communities in the Borscht Belt? The Erie Canal brought thousands of immigrant workers to dig "Clinton's Ditch," and many of them stayed. And what is the reason why there is a French Festival and parade in Cape Vincent in the North Country? This list could go on and on.

But let's talk about the Irish Alps in this chapter. For many generations, large groups of Irish immigrants settled in the Catskills around East Durham in Greene County. They came, like the Jews before them, to set up bungalow camps and small communities to which they could escape the sweltering summer mug of the five boroughs of New York City.

One camp begat another and then another, and soon small groceries would pop up to provide the visitors with food items. Then larger resorts took hold, places with swimming pools, tennis courts, massive dining rooms, and a tavern where Irish food would be served to the accompaniment of an Irish tune emanating from the jukebox.

By the 1950s, there were more than fifty of these Irish resorts around Greene County, located about two hours north of the George Washington Bridge.

The main Irish destinations were the small villages and towns of lower Greene County. Places like Leeds, Oak Hill, Cairo, and Cornwallville. If there was a Dublin to be found in the Irish Catskills, it would be East Durham.

East Durham had the most resorts, bungalow colonies, Irish taverns, and resorts back in the day. Today, although significantly dwindled in numbers, you can still find a few big resorts, like the Blackthorne Resort, and several other smaller places.

Although the crowds are smaller now in the summer, and other Irish destinations have popped around the state, it is still comforting to know that you can pull into East Durham some Saturday afternoon and be assured you can get a meal of Bangers and Mash, Gaelic Chicken, or even Irish Shepherd's Pie at the venerable Shamrock House restaurant on Main Street. It has been a favorite for more than eighty years.

And after your meal, you can drop by McGrath's Tavern and have a pint of Guinness and enjoy some lively live Irish music and maybe even dance a jig with your sweetie.

In this part of the Catskills, all roads lead ye to East Durham.

Website: https://www.shamrockhouse.com

17

ELMIRA, CHEMUNG COUNTY

"HONORING THE PAST; BUILDING THE FUTURE"

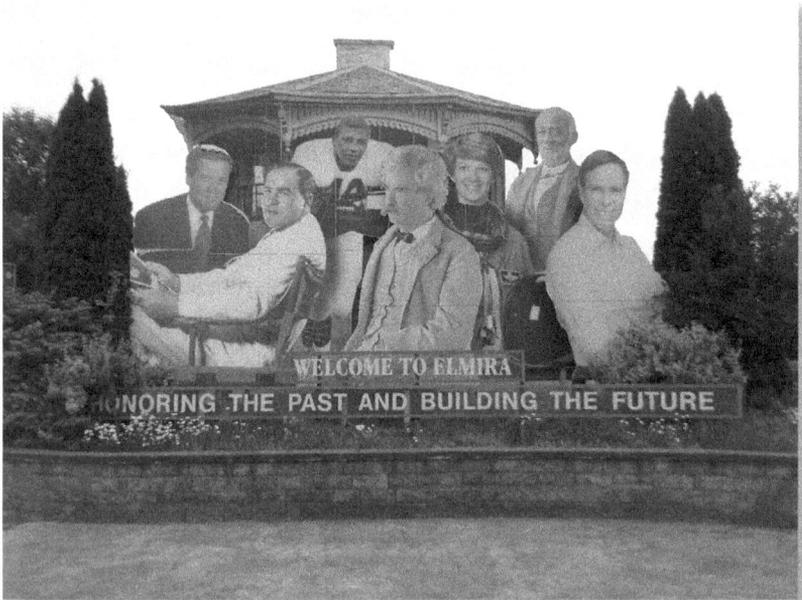

To be fair, if the welcome sign for Elmira, New York, were just the text, it would not have made it into this book. Let's face it, hundreds of communities honor their past and build for the future.

But it is the images of some of the most famous citizens to come out of Elmira that make this welcome sign so compelling. Erected in 2003,

many refer to it as the city's "Mt. Rushmore." So let's get to work and unpack this excellent sign

From left to right, we start with **Brian Williams**. The famous NBC newsman was not born in Elmira (his birthplace is Ridgewood, New Jersey), but he spent nearly ten years of his youth living in the city. He joined NBC News in 1993 and became anchor of *NBC Nightly News* in 2004. In 2015, his illustrious career was derailed after he had to apologize for fabricating a story about his time during the war in Iraq. He was suspended by the network and eventually began reporting for MSNBC.

Hal Roach (1892–1992) is next. One of the great names of early Hollywood, Roach was a dominant figure as a producer and director in the early part of the twentieth century. He is credited with giving the world Laurel and Hardy and the *Our Gang* comedies. In 1984, he was awarded an honorary Academy Award for his contributions to film. Roach is buried in Woodlawn Cemetery in Elmira.

Next to Roach is legendary football player **Ernie Davis**. He was born in Uniontown, Pennsylvania, but moved to Elmira at the age of twelve. In 1961, "The Elmira Express" became the first African American player to win the prestigious Heisman Trophy. He was a football star at Syracuse University and later was signed with the Washington Redskins. His NFL career never got a start, as leukemia claimed the life of this national sports figure at the age of twenty-four. Davis is buried in Woodlawn Cemetery in Elmira. There are statues of Ernie Davis in both Syracuse and Elmira.

Mark Twain, "America's Storyteller," was born in Florida in 1835 as Samuel Langhorne Clemens. One of our country's most legendary writers and public figures, Twain met Olivia Langdon, a native of Elmira, in the 1860s, and they were married in Elmira in February 1870. Twain visited Elmira frequently, lived there, had a famous writing studio in the city, and was buried in Elmira after he died in Connecticut on April 21, 1910. His grave at Woodlawn Cemetery is one of the most visited in Upstate New York.

Eileen Collins was born in Elmira on November 19, 1956. She was a NASA astronaut for many years and was the first female pilot and female commander of a NASA Space Shuttle. Eileen Collins joins Ernie Davis, Hal Roach, and fashion designer Tommy Hilfiger (all on the welcome sign) as graduates of the city's Elmira Free Academy.

John Jones is one of the city's most honored former residents. He was born in Virginia in 1817. Enslaved in the South, Jones escaped his bondage with a daring 300-mile trek to the North. He settled in Elmira

and became one of the most prominent participants in the Underground Railroad. It was said that he personally aided more than 800 runaway slaves in their journey to freedom. Later in life, Jones was in charge of burying the Confederate soldiers who died in the infamous Elmira Prison Camp (known as "Hellmira"). His meticulous care and record keeping as he buried the "enemy" soldiers were a testament to this good and honorable man. He was paid $2.50 for each Confederate burial, which eventually made him Elmira's wealthiest African American. He is buried in Woodlawn Cemetery.

Tommy Hilfiger, one of America's most famous clothing designers, was born in Elmira in 1951. His menswear line in the 1980s was one of the most popular in the country. He started designing women's clothing in the 1990s and opened a store in Beverly Hills. In December 2005, he sold his clothing brand for $1.6 billion dollars. Hilfiger has suffered with dyslexia since his youth, and he is a major endorser and spokesman of research and charity work raising awareness of the reading disorder.

We agree. That is a mighty impressive Mt. Rushmore!

Mark Twain: https://marktwainstudies.com/about/mark-twain-in-elmira/

18

FREDONIA, CHAUTAUQUA COUNTY

"AMERICA'S FIRST GAS WELL"

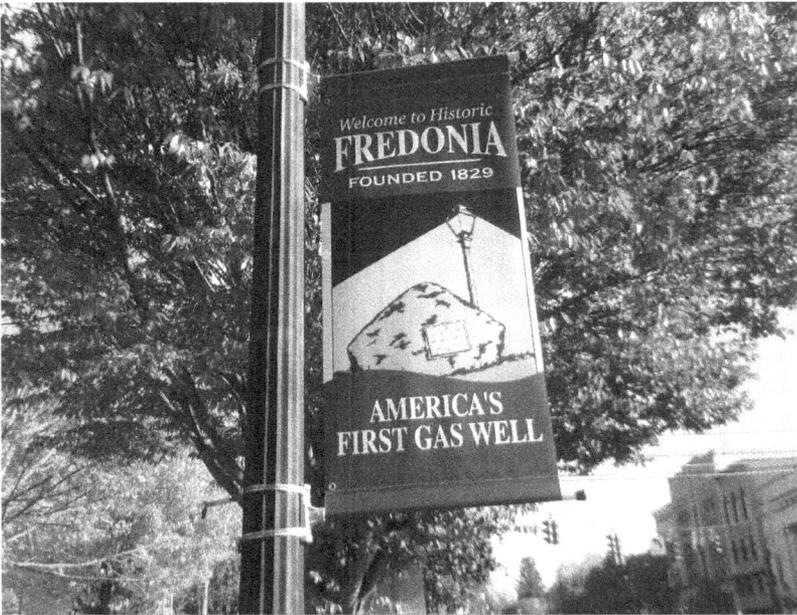

Fredonia sits near the coast of Lake Erie in far western New York. It has a pretty and practical village green in the center of its downtown business district. Actually, the green, the center of community activities, is two side-by-side parks. They offer walking paths, park benches, leafy shade trees, historic fountains, and a band gazebo.

Fredonia is proud of the fact that it was the home of America's First Gas Well, as all the signs and hanging banners throughout the city of 11,000 declare. The well, located on West Main Street, was dug by hand in 1821 by William Hart. He capped the twenty-seven-feet deep well with his wife's washtub and then directed the gas to a nearby retail block using hollowed-out tree trunks connected with tarred old rags to hold it all together. His newfound source of energy produced enough gas to light the nearest store, tavern, and grist mill.

Today, a large boulder near the site of that first gas well carries a bronze plaque telling of its importance to the village.

There are several historic buildings in Fredonia. Among the finest is the Fredonia Opera House across from Barker Commons (the official name of the village green). The building, erected in 1891 as the village hall, is a magnificent Queen Anne "eclectic style" structure that now operates as a live entertainment center as well as the village administrative offices. The opera house is Chautauqua County's only year-round live performance venue.

The major economic engine in Fredonia is the State University of New York at Fredonia. The university is one of the state's oldest, having first opened in 1826. With nearly 5,000 students and staff, the college is an important component to the success of Fredonia. In 1968, a new, modern 250-acre campus was designed in part by I. M. Pei. The school is the westernmost university in the State University of New York system.

A little more than two miles north of Fredonia is Dunkirk, New York. Here you will find several nice, sandy beaches on Lake Erie as well as the historic Dunkirk Lighthouse, one of the state's oldest. The lighthouse is open for tours. It is one of fewer than a handful of lighthouses in Upstate New York that are still active.

Website: https://www.discoverupstateny.com/packages/4678/fredonia/

19

GENESEO, LIVINGSTON COUNTY

"HOME OF THE GREATEST SHOW ON TURF"

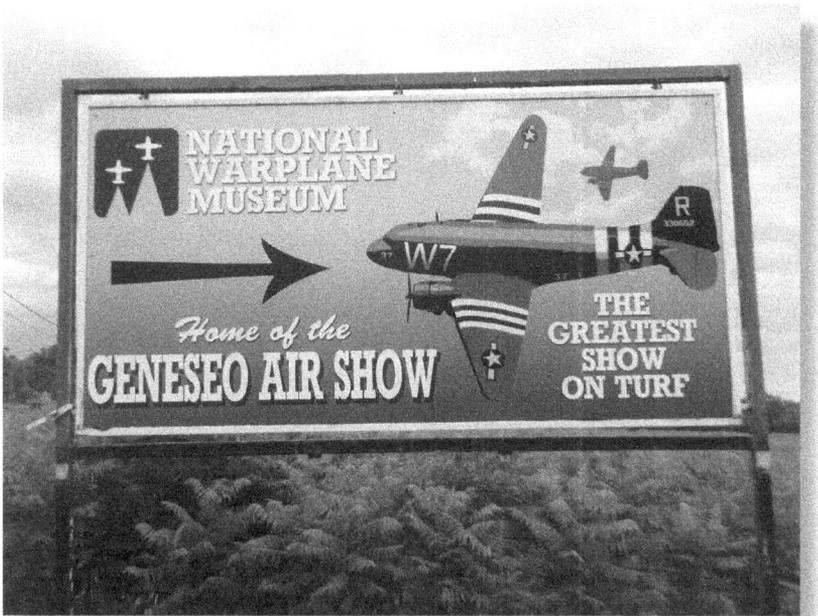

The Wadsworth family moved to the Genesee Valley in the 1780s and founded the town of Geneseo. Over the centuries, the Wadsworths have become one of the most influential families in the valley. As for the town itself, the family has given untold sums to charities and nonprofits over the years, given land to establish the Geneseo Airport, and even donated the 200 or so acres that the State University of New York at Geneseo sits on.

The Wadsworth family members have all participated in a variety of stages of the great American life. From business, to banking, to education, to the military, to politics, the Wadsworths have touched more lives through the years than can ever be counted.

Austin Wadsworth took a great interest in establishing the National Warplane Museum here, at the Geneseo airport. Today it is an amazing place where old warbirds rest until called on again and where old flyboys come to share tales of the wild blue yonder. Each year the museum plays host to the Geneseo Air Show, called "The Greatest Show on Earth."

This writer has attended the show, and it is a thrill not soon forgotten.

Warplanes, mostly from the World War II era, dot the runway, allowing visitors to come up and get selfies with the storied planes of the greatest generation. Pilots and mechanics alike enjoy commiserating with the show attendees, and the crowd can number well into the thousands.

The highlight is when the planes take to the skies. As they zoom overhead, dipping and diving, one only has to let one's imagination go free to picture these planes in combat. Paratroopers jump from the planes overhead, and when their billowy chutes open, loud cheers accompany the jumpers all the way to the ground.

The C-47 Dakota cargo plane is one of their most cherished planes. It is a true World War II veteran, still flies, and still carries the white stripes on its wings, signifying it as part of the D-Day invasion.

The one year I attended the air show, the superstar of them all was the famed Memphis Belle. When this giant plane appeared on the horizon and got larger and larger and louder and louder over our heads and then did a slow wide turn so we could see the entire plane in all its glory, well, let me tell you, each adult was a kid again, thrilling at every moment of the display.

And, as if that weren't enough, rides on the warplanes are available during the air show!

While in Geneseo you should plan a visit to the Wadsworth Homestead at the end of Main Street. The house is one of the most magnificent mansions in western New York, and tours are totally fascinating. Will Wadsworth, a sixth-generation family member, conducts the tours.

National Warplane Museum: https://nationalwarplanemuseum.com/

20

GORHAM, ONTARIO COUNTY

"BANDSTAND OF THE FINGER LAKES"

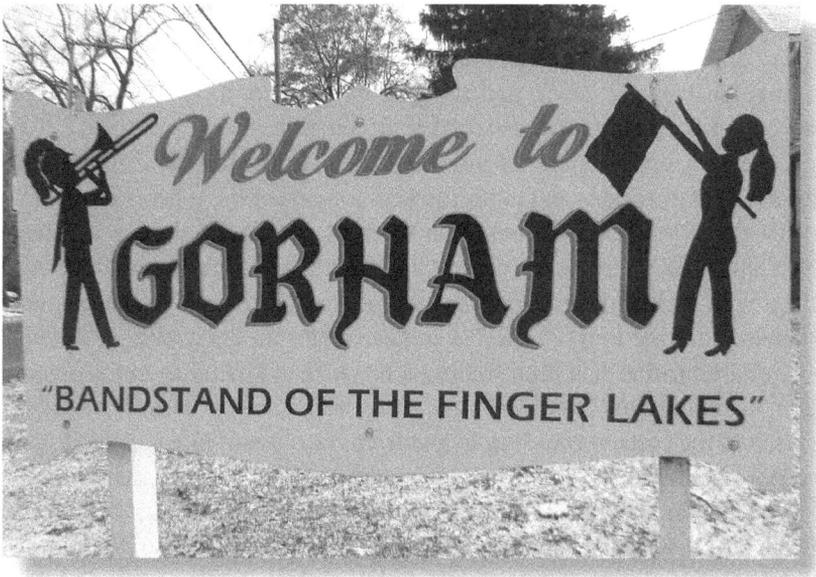

Although not unique to Upstate New York, there is something so Norman Rockwell–like about a small community hosting a big pageant of bands.

On the days of these events, thousands line the streets of town, swelling its population tenfold. At the given moment, dozens of high school marching bands and performance groups start to wind their way along Main Street, lockstep with the cadence of a drum and bugle corps, with flags flying, school banners on full display, brass instruments gleaming

in the morning summer sun, with teenage girls in short skirts carrying pom-poms strutting out front. And, if you are lucky, a drum major will be at the head of the marching unit with a tall fur hat, baton, and crisp, white uniform, prancing in dramatic form while marshaling his band with orders blasted out from the silver whistle clenched in his teeth.

And while the number of trombones might not number seventy-six, the Broadway musical *The Music Man* has nothing on this. Yes, it is that good.

Several small communities do this year after year. For example, in Seneca Falls (Seneca County), they have been doing this for more than a half-century. In the small town of Sherburne (Chenango County), they have been doing it for more than seventy years.

And the Finger Lakes town of Gorham (population under 5,000) is no piker when it comes to holding one of these musical extravaganzas, either. They have been welcoming visitors to come and enjoy a day of brass, drums, and flag twirlers for more than six decades. These events are a huge deal to this town, and the visitors have contributed some pretty important economic largesse when they come.

With a large number of marching bands in the parade, incorporating hundreds of musicians and performers, this is one of the most popular family events of the summer. And when the host school, the Marcus Whitman Marching Wildcats, passes through Main Street, the hometown crowd showers them with a cheer heard from one end of town to the other. The moniker "Bandstand of the Finger Lakes" is well earned for the good folks of Gorham.

Participation has been waning a bit in recent years as more schools drop marching bands from their extracurricular activities because of budget cuts, and the costs of traveling to and from the pageant pinches the distant school's pocketbooks, but as of this publication the pageant marches on.

Food for thought: Who was Marcus Whitman? Born near Gorham in Rushville, New York, Whitman was a physician and missionary who organized the first major wagon train into the Oregon Territory in 1843. The Whitman party settled in what is today the city of Walla Walla, Washington. Here he ministered to the Cayuese Indians while practicing his missionary work. In 1847, the Cayuse blamed Whitman for an outbreak of measles that killed approximately 200 members of the tribe, and in retaliation they murdered him, his wife, Narcissa, and many other settlers in what is widely known as the Whitman Massacre.

Gorham Pageant of Bands: https://www.facebook.com/gorhampageant/

21

GRANVILLE, WASHINGTON COUNTY

"THE COLORED SLATE CAPITAL OF THE WORLD"

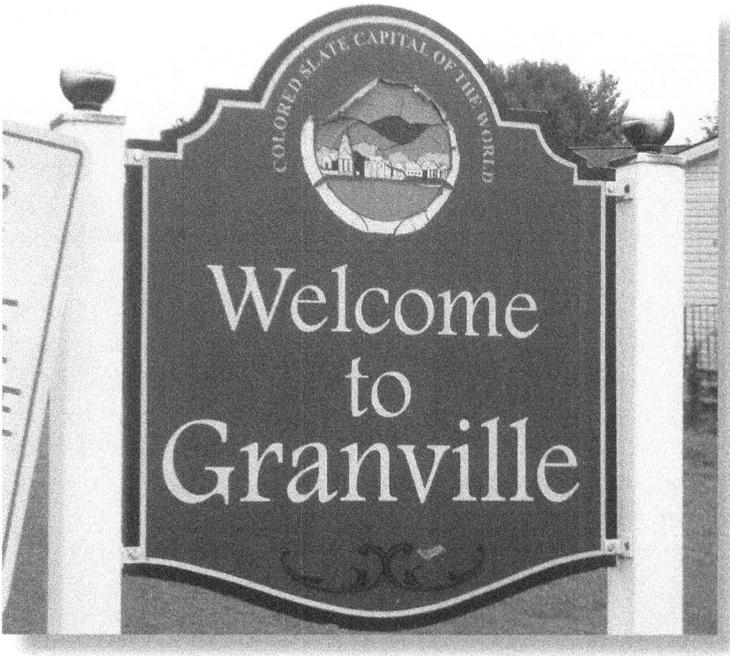

My only complaint about Granville's welcome sign is that its historical reference is too small to read from a passing car. The letters should be big and bold because Granville has a fascinating story to tell!

Located in "Slate Valley," a mineral rich area that runs about twenty-five miles along the New York/Vermont border, Granville has long been

the only place in the world where, using precision techniques and a lot of human and mechanical muscle power, you can put a shovel in the dirt and pull out pieces of beautiful, naturally colored slate. Obviously, it isn't that simple, but you get the idea.

You can find a rainbow of slate in the area quarries, including red, green, and even purple slate slabs lying underground in Slate Valley. And architects, home designers, contractors, and development planners could not be happier. Of course, the standard gray slate is mined here in abundance.

Granville is much more than just pieces of colored slate, however. The real story here is the immigrant labor force that came in the mid-1800s to work the quarries. It was hard, physical labor. Safety laws were nonexistent, and many men were injured and even died in the course of their long days mining slate.

The first immigrants to come to Slate Valley were from Wales. Soon waves of Italians, Irish, Poles, and other Eastern Europeans joined the workforce. They lived in a United Nations–sort of community in Granville. They continued to speak their native languages, eat their national foods, and celebrate their own cultural holidays. And, apparently, they all got along quite well.

The Slate Valley Museum tells the story of the slate industry in dramatic fashion. Upon entering, the first thing you see is perhaps the largest dump truck ever made. This was the kind of behemoth that rumbled up and down the crude dirt roads that connected the various slate quarries in the 1950s. Before that, slate was moved by train, wagons, and men. In the museum you can see a replicated quarryman's shack, where the precious slate was actually cut into pieces. Docents will gladly slide a heavy piece of the rock into a nineteenth-century cutting machine and let visitors cut their own piece.

The work in the mines was backbreaking and very dangerous. This is obvious from the large black and white archival photographs of men hanging from chains deep in a quarry hand cutting slate as they dangled a hundred feet above the quarry floor.

The labor was tough, but the result was one of the most beautiful arrays of natural stone ever produced in the world. The grand entrance floor of the Slate Valley Museum appears to be covered with an attractively designed Native American or Amish patterned quilt. It is actually a layout consisting of more than 4,000 individual pieces of slate representing the seven different natural colors mined in Granville.

While in Granville, visit the Pember Library and Museum, which houses more than 7,000 historical items. Also, the Sheldon Mansion Bed and Breakfast is a magnificent home that was built by one of the original slate barons. At 10,000 square feet and with thirty-four rooms, it is one of the largest homes in Granville. Frederick Sheldon owned several quarries and controlled the largest quarry provider of the precious red slate in the area. The mansion is the only building in the world built with red slate walls.

The 150-year-old Granville D&H train station is now a completely renovated bed and breakfast. It is gorgeous. The rooms carry railroad themes such as the Side Car Room, the Conductor's Room, the Freight Office Room, and (of course) the Caboose Room.

Slate Valley Museum: https://www.slatevalleymuseum.org/

22

HAMILTON, MADISON COUNTY

"BIRTHPLACE OF JOHN VINCENT ATANASOFF, INVENTOR OF THE COMPUTER"

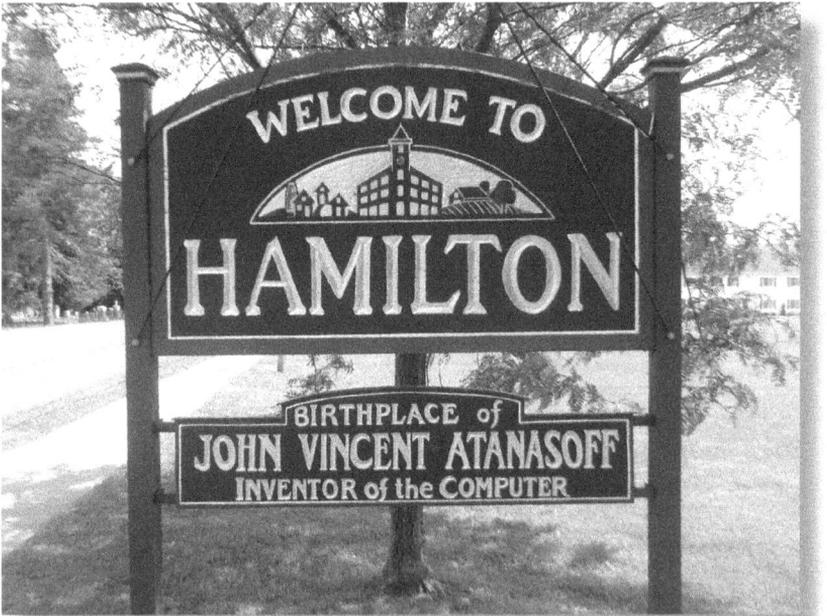

If there is such a thing as a Charles Babbage Fan Club, no doubt it will take issue with the honorific bestowed on Hamilton's native son, John V. Atanasoff. Babbage's name almost always pops up when doing a Google search for "Who invented the computer?" The English mathematician is

credited with taking the burden of data application away from humans and applying it to a mechanical tabulating device, but that was in the 1830s.

So, who is John Vincent Atanasoff?

He was born in Hamilton on October 4, 1903. His father was an electrical engineer, and his mother was a math teacher, so we can assume that numbers came easy to him. While attending college at Iowa State University, he still enjoyed math analysis studies but apparently grew tired of the slow-acting tabulating machines of the day. With a fellow student, Clifford Barry, he set out to create a new computing device that would limit errors and act more rapidly. Their Atanasoff-Berry Computer was created in 1939.

Years later, after his computer started to gain widespread use, Atanasoff was involved in several lawsuits and patent litigation. In the landmark 1973 federal case of Honeywell vs Sperry Rand, the adjudicating judge finally declared, on October 19, 1973, that John V. Atanasoff was indeed the inventor of the first electronic calculating digital computer.

Hamilton is a picture-perfect community of 4,250 residents nestled in the bucolic bosom of Madison County. It is home to Colgate University. The college, founded in 1819, is located near the heart of the village and is considered to have one of the most beautiful campuses in the country. It is famed for its "Willow Path." This long, willow tree–shaded path is part of the college's folklore. School legend has it that if you kiss your sweetheart for the first time along the Willow Path, you will end up marrying her. Those who in fact did this over the years return to Colgate to reenact that first kiss in the same exact spot.

Hamilton, New York: https://www.hamiltonny.com/

23

HOBART, DELAWARE COUNTY

"BOOK VILLAGE OF THE CATSKILLS"

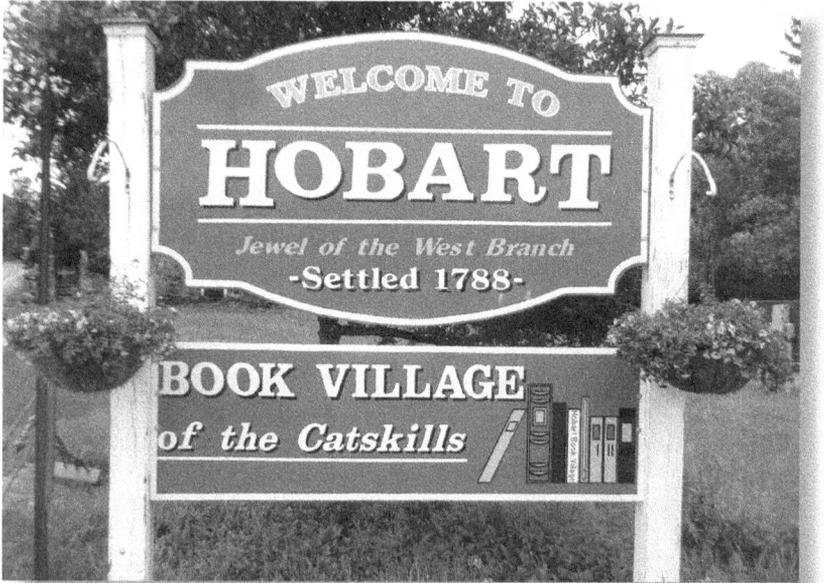

Build it and they will come. On weekends. . . .

Hobart is a very small village of fewer than 500 residents. It had seen better days when a local entrepreneur decided that this idyllic riverside village would be the perfect place to buy books. To have lots of bookstores. In fact, have a whole village of books!

And the Book Village of the Catskills was born.

Today there are more books in Hobart than you can shake a stick at. A fluctuating number of a variety of bookshops, somewhere between six and ten at any given time, has made this tiny map dot a destination of sorts. The bookstores carry thousands of books; some are priceless antiquarian works and others are potboiling page turners, both paperback and hardcover.

On weekends you can see cars lining each side of the little Main Street (Rt. 10) with folks ferrying armloads of books out of the different stores and placing them in the trunks of their expensive cars. How fun! Once the metropolitan New York newspapers sniffed out this place, the jig was up.

Make no mistake about it. This is not akin to a yard sale with piles of random books. Each store has taken great pains to curate its inventory and present it in an accessible and attractive manner.

This is a lovely community nestled along the banks of the slow-moving (usually) West Branch of the Delaware River. Its beauty is also noted on the welcome sign, referring to the village as the "jewel of the river."

There is no question that this gorgeous area of Delaware County remains a solidly agricultural region. Dairy is king here. But here, in what some would call the middle of nowhere, rising like an apparition on the landscape, is an adorable place filled with books just waiting for you to come and say hello. Because of the weekend success of the Book Village of the Catskills, other stores and shops have popped up along Main Street over the years, including a couple of country dining spots.

The village is also becoming known as a center for arts and literary culture, as it hosts the annual Festival of Women Writers, several art shows, author readings and signings, as well as the very popular Winter Respite Lecture Series, all of which keep the village a year-round destination.

We suggest you plan your day by starting at Wm. H. Adams' Antiquarian Books, which happens to also be the very first bookshop in the village. Featuring three floors of artfully displayed fine books, they also offer tea in a bright, cordial atmosphere that makes both the collector and the browser feel welcome.

From the Adams' bookstore you are perfectly positioned to walk up one side of Main Street and down the other. The stores will be glad to see you, and we just know you will go home with a bargain or two.

Like other villages in Europe that have declared themselves book villages, so too has Hobart. It has planted the flag and is determined to

welcome more bookstores soon to its ever-growing list. It is the only book village east of the Mississippi, and the good folks here like that just fine, thank you very much.

For a list of book shops in Hobart: http://www.hobartbookvillage.com/about-us.html

24

HOOSICK FALLS, RENSSELAER COUNTY

"GRANDMA MOSES COUNTRY"

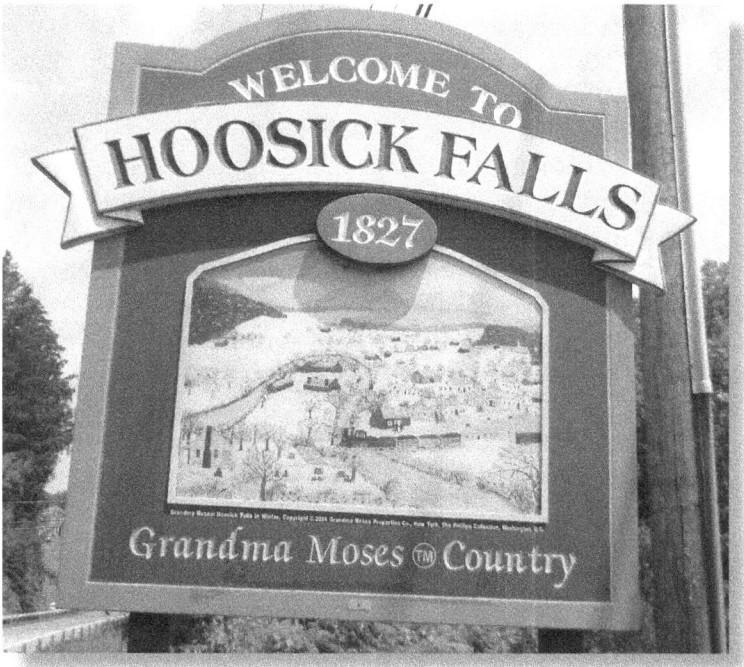

It is readily obvious to any art fan that this region, near the Vermont border, is unmistakably Grandma Moses Country.

The folk artist was born in Greenwich, New York, in 1860, lived for many years in Eagle Bridge, and spent her last years in Hoosick Falls. All are within a dozen miles of each other. Her grave is much visited in Maple

Grove Cemetery in Hoosick Falls. The gravestone carries her real name, Anna Mary Robertson.

Grandma Moses herself looked like she just walked out of a Norman Rockwell painting. She was a diminutive, flower hat–wearing, lace-collared throwback to another era. She wore rimless glasses and had a tart, no-nonsense tongue. When interviewed by famed journalist Edward R. Murrow once, he asked her how hard it was to be an artist. Her retort was, "Just pick up a pencil. Anyone can draw."

Moses didn't start painting until well into her seventies. She drew what she knew and where she lived: her neighbors and surroundings. Her works were peopled with checkered tablecloths on the clothesline, kids and dogs playing in the front yards, and horse and buggies trotting down a back dirt road. The porches in her paintings were always filled with old-timers, and the swimming holes were always filled with the young ones. Originally she sold her paintings for less than five dollars each out of the front window of a Hoosick Falls drugstore.

Famed art collector Louis J. Caldor wandered by the drugstore one day in 1938 and was immediately smitten with the crude, naive, and utterly charming paintings. He bought all the store had and asked where the painter lived. He called Grandma Moses and told her he was coming to her house in Eagle Bridge to buy ten more. The story is told that she only had nine paintings on hand but broke a large one in half and sold him ten.

Caldor took his paintings back to New York City, where they were a sensation. One year later her paintings were the focus of a major exhibition at the Museum of Modern Art titled "What a Farm Wife Painted." Thousands came to see the little white-haired lady with the painter's magical touch. A legend was born.

She was an engine of an artist. She produced hundreds of works of art, mostly the after the age of seventy.

On September 19, 1960, *Life* magazine honored her with a full photographic spread in tribute to her 100th birthday. Governor Nelson Rockefeller declared that day "Grandma Moses Day." When she died at the age of 101, on December 13, 1961, she was mourned on a national scale. President John F. Kennedy said, "Both her work and her life helped our nation renew its pioneer heritage and recall its roots in the countryside and on the frontier. All Americans mourn her loss."

So how does a small community honor such a towering figure? With a painting, of course.

The Hoosick Falls welcome sign features a large image of one of her most famous, and most reproduced, paintings titled "Hoosick Falls in Winter." She completed the work in 1944, and it is now in the permanent collection of the Phillips Collection in Washington, DC. Founder Duncan Phillips, a great admirer of the painter, was the first to acquire a Grandma Moses painting for a museum.

The Bennington (Vermont) Museum of Art has the largest public collection of her paintings in the United States. In 1972, the original one-room schoolhouse that little Anna attended was moved intact to the museum site. The museum is only ten miles east of Hoosick Falls, just over the Vermont border.

Bennington Museum of Art: https://benningtonmuseum.org/

HORNELL, STEUBEN COUNTY

"HOME OF BILL PULLMAN"

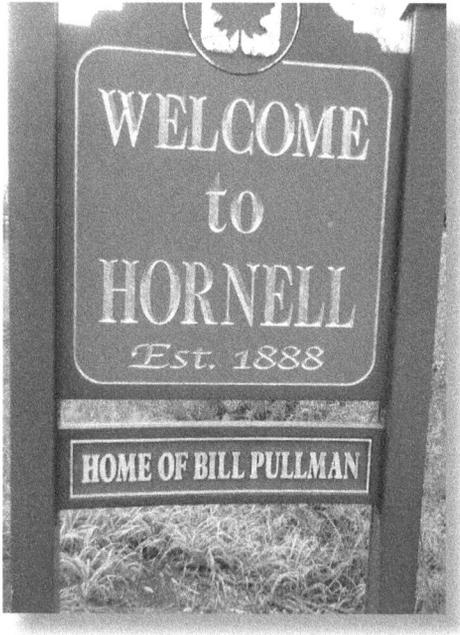

This is a curious one. Hornell, a small Southern Tier community of about 8,500, had several different options when erecting its welcome sign. Hornell was once known as the "Maple City" because of all of its majestic maple trees throughout the city. It could have recognized itself as holding one of

the largest St. Patrick's Day parades in western New York, which attracts thousands of visitors annually.

But the city decided to honor a hometown native who went on to fame and fortune. And it had plenty to choose from. Probably the three finalists would have included Thomas Murphy, born in Hornell on December 10, 1915. He was the dynamic CEO of General Motors during the 1970s, a time when GM was selling more than 10 million cars and trucks a year around the world. Or the city leaders could have picked Vice Admiral Lyndon Spencer for its welcome sign. Spencer was born in Hornell on January 26, 1898. He had a long and storied career with the United States Coast Guard. He commanded the USS Bayfield, the flagship of the US Naval Task Force during the invasion of Normandy on D-Day, June 6, 1944.

All good and honorable men. But the city went a different route in its naming honors. I mean, how many people have ever heard of Tom Murphy or Lyndon Spencer? Instead, they went with a name that a lot of people would recognize, a name that is very familiar in entertainment circles.

So, it is actor Bill Pullman for the win!

He was born in Hornell on December 17, 1953. He is a true son of Upstate New York, having graduated from Hornell schools and then attending two nearby colleges, the State University of New York at Delhi (where he later taught theater) and then the State University of New York at Oneonta.

He is one of the hardest-working actors in show business. He has made at least one movie per year since he debuted in 1986. And although generally flying a bit under the Hollywood press radar, he has starred or costarred in several hit movies that have raked in hundreds of millions of dollars. Among them are *Ruthless People* (1986; net $55 million), *Spaceballs* (1987; net $17 million), *Sleepless in Seattle* (1993; net $200 million), *While You Were Sleeping* (1995; net $150 million), *Casper* (1995; net $224 million), and *Independence Day* (1996; net $825 million). The last-mentioned film still stands as one of Hollywood's earliest mega-box office hits.

The actor also had a prolific Broadway acting career, appearing in plays by David Mamet, Edward Albee, and others. Although he spends much of his time at his ranch in Montana, Pullman remains close to his hometown. In fact, he is on the Board of Trustees of Alfred University, which is located just ten miles from Hornell. He was given an honorary degree from the college on May 14, 2011.

So, we agree, Hornell. Bill Pullman for the win!

Hornell, NY: https://www.corningfingerlakes.com/explore-the-area/our-communities/hornell/
Bill Pullman: https://www.billpullman.org/

26

HORSEHEADS, CHEMUNG COUNTY

THREE HORSES ON SIGN

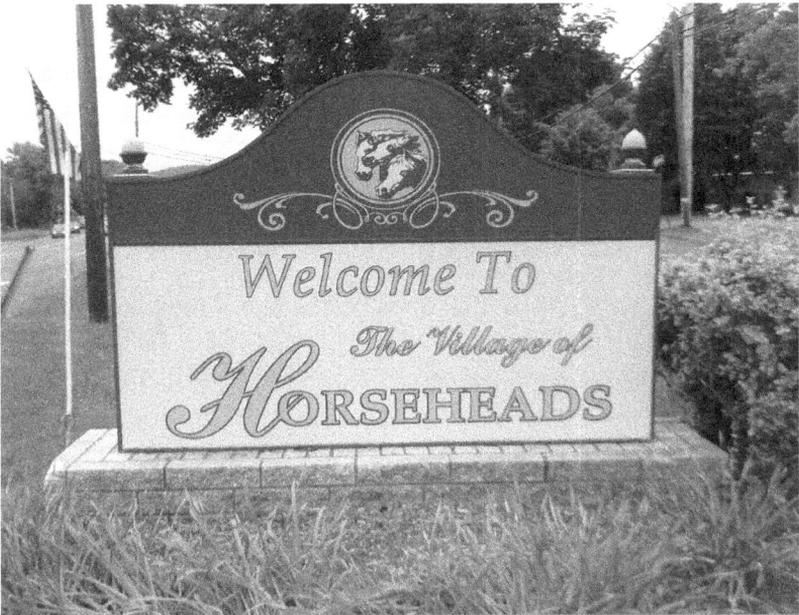

Because there is an absence of text on this sign to explain the unusual meaning of the name of the village, a little history is called for.

The image of the three horse's heads on the sign carries a significant meaning to the residents of the small village of about 6,500.

During the Revolutionary War, American Major-General John Sullivan and his army of about 5,000 soldiers marched through central-northern

Pennsylvania and on up to western New York specifically charged with routing Loyalists and nations of the Iroquois Confederacy, which had sided with the British for the war. The campaign exercised the infamous "scorched earth" systematic destruction of Iroquois villages and crops along his route.

Accompanying his army was a contingent of about 1,500 US military pack horses, providing an ever moving, fluid encampment of supplies, food, heavy equipment, and ammunition.

The trip was a long and difficult one over thickly forested mountain, bug-infested swamps, and uncharted river valleys in a little-populated area. The campaign was particularly hard on the pack horses.

After a difficult 450-mile trudge, General Sullivan made the wrenching decision that many of the pack horses were simply unfit and unwell to carry on. A large number of the horses were put down here in the area of present-day Horseheads on September 24, 1779. The horses' remains went unburied.

Sometime later, when small groups of Native Americans returned to resettle this area, the bleached skulls of the pack horses were discovered. They were arranged as ominous "trail markers" leading into the village. When permanent settlers re-created the village, they named it "The Valley of Horses Heads," which was later shortened to just Horseheads. While efforts over the years have been made to change this strange name to North Elmira, citizens have resisted the efforts, and so one of the strangest town names in the state remains.

Horseheads is the first and only town and village in the United States dedicated to the service of the American Military Horse. A twenty-eight-square-mile memorial, unparalleled in American military history, is the proud distinction that enshrines the town and village of Horseheads, New York.

Be sure and seek out a magnificent statue located in front of the Horseheads Police Department. It is a bronze life-size statue of a military pack horse, depicted as if in service in the days of the Sullivan Campaign. Like so many other firsts in this small village, it is the only statuary tribute to these animals anywhere in the United States. It was erected on May 18, 2013.

You can find the image of the three horses' heads here on everything from banners to shop windows and on the website of the Horseheads Central School website.

Horseheads, N.Y.: https://www.lifeinthefingerlakes.com/horseheads/

27

IRONVILLE,
ESSEX COUNTY

"BIRTHPLACE OF THE ELECTRIC AGE"

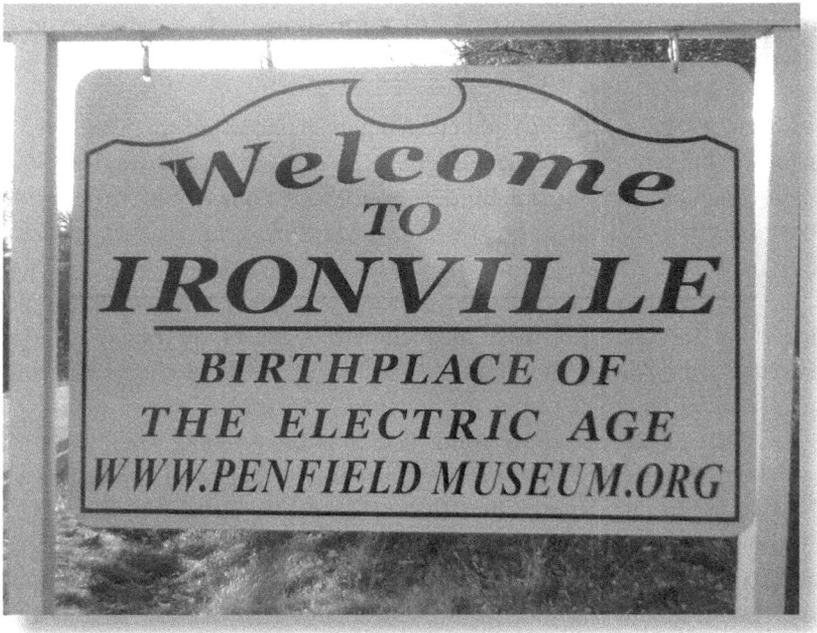

This is a good one. If this sign doesn't make you stop and pull out your Google app, nothing will.

Here, deep in the wooded area about five miles west of Crown Point, New York, you will see a most incongruous sign. There really is nothing around the sign, but with a little exploring you will be fulfilled.

The Ironville we speak of here is more of a historic district now than a town. Today, only about a dozen buildings are left to represent the district. In the 1800s, this was a thriving place where the iron industry was king.

There were several iron works in this mountainous region, although today their memories can only be found in the Penfield Museum, one of the dozen buildings in the Historic District. Hundreds of men worked the iron mines back in the day, and it was here that the first commercial application of the new wonder of electricity took place.

The DNA of this discovery runs back to Joseph Henry, a physicist who was tantalized by the discovery of some magnetic rocks found around the iron works. In 1829, he tweaked his discovery and created a new independent magnetic tool. When he cobbled together some magnetic rocks with insulated wires, he was able to create a magnetic force that was rigged up to ring a bell from a distance. A first for its time. In fact, certainly on a much less heralded acclaim, Joseph Henry could also be called "The Father of the Electric Doorbell."

Henry refined his idea and created a magnetic wheel that was able to separate different classes of metal filings in a new, efficient way. He sold these machines to the giant Burden Iron Works Company in Troy, where they drew national attention. He also made a powerful magnet for Yale University that was able to lift more than 2,000 pounds.

It is all very technical and difficult to explain the geological and industrial application of these magnetic devices made in Ironville at the Penfield Iron Works. But it is all well documented at the interesting museum that is at the center of the Historic District.

There are several signs in this book that are startling when you first see them. Signs like "Welcome to Whitehall, Birthplace of the American Navy." Or the one in Hamilton that reads "Welcome to Hamilton, N.Y. Birthplace of John Vincent Atanasoff, Father of the Computer." These and others were all new to me. And none is more surprising than to find the "Birthplace of the Electric Age" sign on a remote road deep in the Adirondacks welcoming the visitor to a place that doesn't exist anymore.

Oh, and Joe Henry was no country bumpkin who just stumbled upon his discovery. He was a brilliant and learned man. He was a mathematics professor at the Albany Academy, the chair of the Natural History Department at Princeton University, and the first secretary of the Smithsonian Institution in Washington, DC.

The Penfield Historic District was listed on the National Register of Historic Places in 1974.

Museum Website: https://www.penfieldmuseum.org/

JAMESTOWN, CHAUTAUQUA COUNTY

"BIRTHPLACE OF LUCILLE BALL.
BIRTHPLACE OF ROGER TORY PETERSON.
HOME OF ROBERT H. JACKSON."

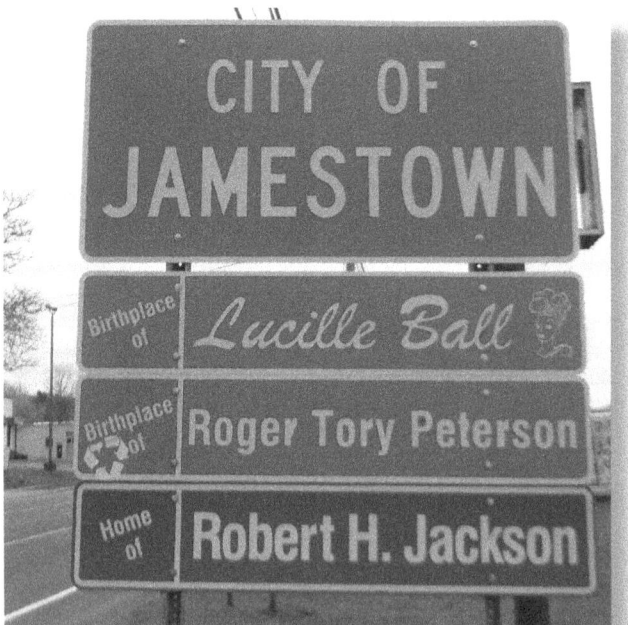

The fragile fortunes of this once economic engine in western New York took a turn for the better when their beloved daughter, Lucille Ball, came home for good.

The legendary comedienne died in Hollywood in 1989 and was buried in Forest Lawn Memorial Park, the "cemetery to the stars." Later, in 2003, her children, Lucie and Desi Jr, made the decision to take their mother's ashes and reinter them in the Ball family plot in her hometown of Jamestown. Once there, people from all over the country began making the pilgrimage to the city's Lake View Cemetery to pay their respects to "America's Queen of Comedy."

What followed was a public relations master stroke. A Lucy-Desi museum opened up, statues and historical markers commemorating Lucy and her life sprang up, blank walls in the downtown business area of the city all of a sudden sported enormous murals of Lucy eating chocolates along the speeding conveyor belt or grimacing her way through her Vitameatavegamin commercial, and later the city welcomed the National Comedy Museum. Tourism flourished.

The epitaph on her tombstone, which is decorated with the large heart that once opened her iconic *I Love Lucy* TV show, says it all.

"She's Come Home."

Roger Tory Petersen was born in Jamestown on August 28, 1908. He is remembered as one of the founders of the American environmental movement. He was famed as a bird expert, master illustrator, and environmental activist. His 1934 illustrated *Field Guide to Birds* was his most famous work, became a wildly popular bestseller, and today is even considered to be the "Bird Bible." The Roger Tory Peterson Institute of Natural History stands today in his hometown as a tribute to a life filled with good works.

Robert H. Jackson was not born in Jamestown, but close. He was born in Frewsburg, New York, just five miles to the east. He was a towering American jurist who served in the highest legal offices in the country including US solicitor general, US attorney general, and, from 1941 to his death in 1954, associate justice on the highest court in the land, the United States Supreme Court.

He is most famous, however, as being the chief prosecutor against the Nazi war criminals at the Nuremberg War Crime Tribunal. When Justice Jackson died, his funeral was held at St. Luke's Church in Jamestown and was attended by hundreds of mourners including New York Governor Thomas E. Dewey as well as all eight of the remaining members of the US Supreme Court.

The Robert H. Jackson Center, whose mission is to "advance public awareness and appreciation of the principles of justice and the rule of

law, as embodied in the achievements and legacy of Justice Jackson," is located at 305 E. 4th Street in Jamestown. The Center acts as a museum to Jackson and includes personal memorabilia, archival photographs, manuscripts and speeches, and documents Jackson's time as the prosecutor of the Nuremberg war trials.

Website: https://lucy-desi.com/

KINDERHOOK, COLUMBIA COUNTY

"HOME OF MARTIN VAN BUREN, 8TH U.S. PRESIDENT"

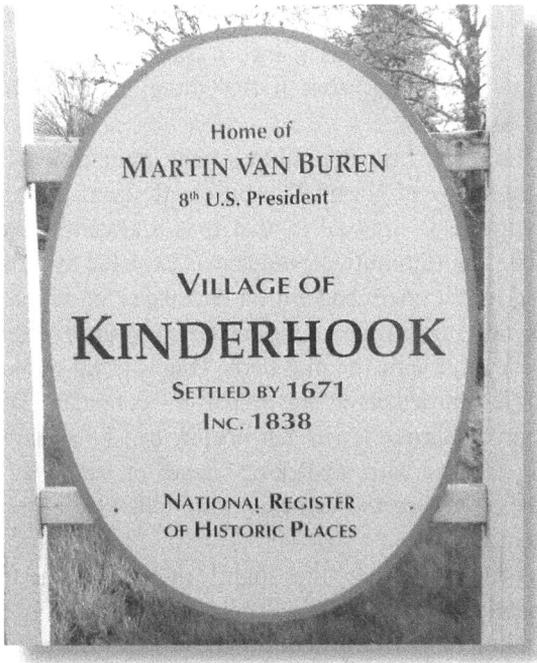

In the pantheon of great US presidents who have a long and well-recorded history with New York State, such as both Franklin and Teddy Roosevelt, the name Martin Van Buren might not jump right out of your memory bank.

But in his village of 8,500 residents tucked into a gorgeous corner of Columbia County, the name rings true. Although tiny in size (he stood barely five feet six inches tall), "Little Van" cast a giant shadow in both New York and national politics. He served as a New York State senator, an ambassador to the United Kingdom, New York State attorney general, New York State governor, US secretary of state, vice president of the United States (under Andrew Jackson), and was elected the eighth president of the United States, serving from 1837 to 1841. There are many remembrances of Kinderhook's most famous native son in the small village. Three of the most visible are his house, his statue, and his grave.

Lindenwald is the name of the president's thirty-six-room mansion located in the heart of the village. He purchased the home while still living in the White House and moved into it permanently at the end of his administration in 1841. The home was also a working farm covering 125 acres. The president died in this home on July 24, 1862, at the age of seventy-nine. The house was named a National Historic Landmark in 1961. Tours are given, and between 10,000 and 15,000 visitors tour Lindenwald each year.

Across the street near the village's main intersection is a wonderful life size bronze statue of Martin Van Buren. It was dedicated on July 14, 2007. The sculpture is unusual in that it is a seated statue rather than a standing one. The diminutive president is depicted as sitting on a park bench, dressed in his finery and with a newspaper in his hand. The space on the bench next to him is empty encouraging the passerby to share a moment of reflection with the president. This is a fun photo opportunity.

Van Buren is buried about one mile from his home in the Kinderhook Reformed Church Cemetery. His tall obelisk can be seen from the road and is usually adorned with a patriotic wreath or banner of some sort. A historical marker outside the cemetery gate tells of the graveyard's most famous resident.

For a president who today flies slightly under the radar there are many interesting factoids relating to Van Buren's life. He was the first president born in the United State (think about that), was the first president to enter the White House a single man (his wife Hannah had died earlier), and he was the first president to whom English was not his first language (he spoke Dutch at home and learned English in school.)

Website: https://www.nps.gov/mava/index.htm

30

LACKAWANNA, ERIE COUNTY

"HOME OF FATHER BAKER"

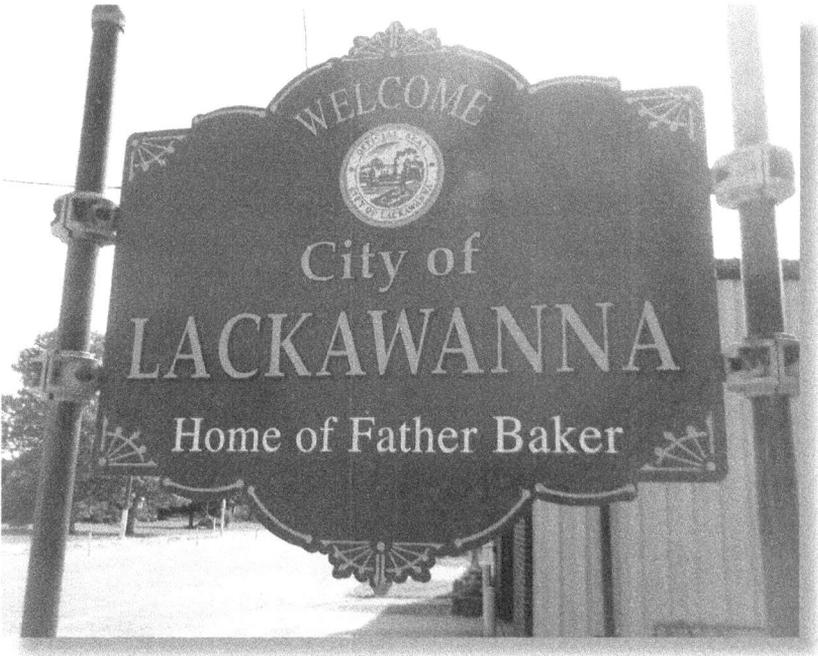

The story of Father Nelson Baker is one of Upstate's greatest tales. He was one of the most important figures in the history of the city of Buffalo, and his legacy ran deep and strong and continues to this day in many ways.

As a Roman Catholic priest and public servant, Father Baker created the largest private charitable network in the United States at the time.

Deeply affected by the harsh conditions by the poor and neglected of the Buffalo area, Father Baker formed a massive, extensive system of charitable organizations that touched all facets of life in Buffalo.

He formed an infant home where unwed mothers could bring their newborns and place the baby in a window anonymously. The infant would then be taken care of by Baker's flock of nuns and nurses. He created a hospital, a boy's orphanage, a school system that went from kindergarten to high school, a trade school, and others.

He did this under the umbrella of his Our Lady of Victory Basilica located in Lackawanna. The basilica, a part of the dioceses of Buffalo, has been called one of the most beautiful churches in North America. Thousands visit it each year.

Father Baker wanted only the finest materials for his basilica, no matter how far around the world the builders had to go to get them. The exterior is made of Georgia marble and the interior is made of forty different kinds of Italian marble. Inside there is an eight-ton statue of Our Lady of Victory made of Carrara marble. The Stations of the Cross feature life-sized figures.

The church is an extravagant, over-the-top work of religious beauty. To visit here is sensory overload. The stained glass is stunning, the many statues are impressive, and Father Baker's remains (he died in 1936) rest eternally in a grotto constructed of black lava rocks from Mount Vesuvius in Italy.

Our Lady of Victory National Shrine and Basilica is located at 727 Ridge Road, Lackawanna, New York. There is a bronze statue of Father Baker, "The Padre of the Poor," just outside the front staircase.

Our Lady of Victory National Shrine and Basilica: www.olvbasilica.org

31

LAKE PLACID, ESSEX COUNTY

"SITE OF THE 1932 AND 1980 WINTER OLYMPICS"

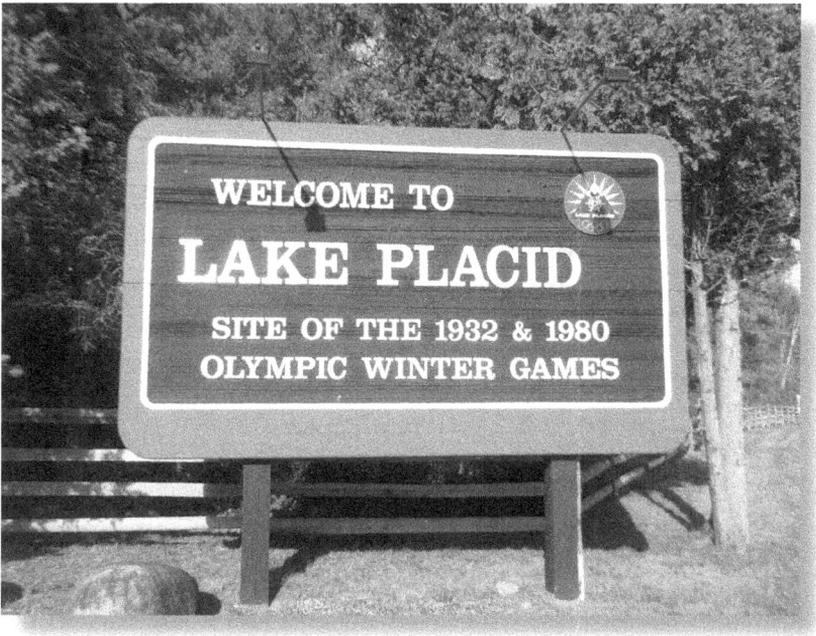

What a remarkable tale Lake Placid has to tell.

This tiny Alpine-like village, with fewer than 2,000 residents, was the center of the sports world, not once but twice, when the best winter athletes from around the globe descended on it for the drama and pageantry of a Winter Olympics game.

While in 1932 most people were still looking for the location of Lake Placid, Godfrey Dewey, one of the wealthiest and most influential residents of the village, was pushing behind the scenes for the Olympics to be held in this winter nature's paradise. He held considerable sway, too. Not just with his fortune, but also with his name and reputation. He was the son of Melvil Dewey, the man who gave the world the librarian's best friend, the Dewey Decimal System. At the time he was also the president of the prestigious Lake Placid Club, an influential social club and hotel that was founded by his father. Its influence in the Adirondacks was significant enough to beat out California in being named the host site for the 1932 Olympics.

With many of the winter sporting venues still in various stages of assemblage, Lake Placid was a perfect place to revisit for the Olympic Winter Games almost a half-century later.

Today, the village is one of the great Adirondack tourist meccas. Visitors can tour, and even partake of, sites well-known to Olympic fans, from the bobsled run, to the towering, crane-like ski slaloms, to the heroic ice skating oval where the "Miracle on Ice" took place when the US men's hockey team bested the vaunted professional team from the Soviet Union. All of these sites, and more, are open to the public for tours.

The picturesque Main Street, tight against the crystal blue water of the village's namesake lake, is crowded with coffee shops, pubs, restaurants, and gift shops whose shelves are packed with every Olympic-themed gift item, piece of clothing, sports object of art, and unusual tchotchke imaginable

The view of the High Peaks around the village is a photographer's dream. The village is also just minutes from Whiteface Mountain ski resort (the state's fifth-highest mountain), and, for the youngsters, Santa's Workshop at the North Pole theme park.

An interesting anecdote about the village is that singer Kate Smith, famed for giving the country Irving Berlin's anthem "God Bless America," lived for forty years on an island here and actually broadcast her top-rated 1930s and 1940s radio show frequently from her personal boathouse. The singer is buried in a large pink mausoleum at St. Agnes Cemetery in the village.

Website: http://www.lpom.org/

32

LEROY,
GENESEE COUNTY

"BIRTHPLACE OF JELL-O"

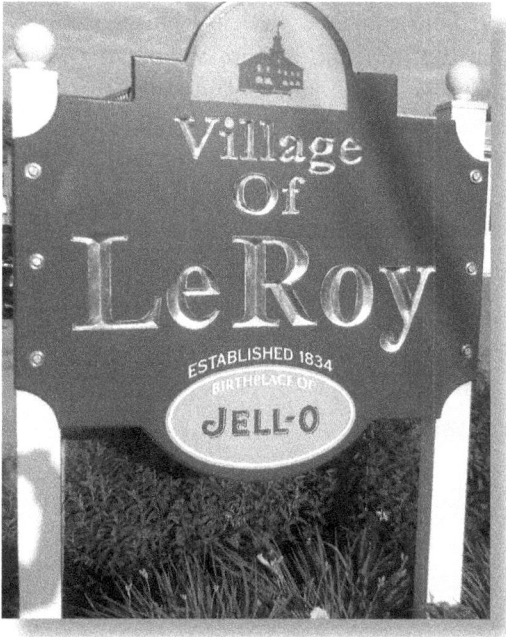

Everything had to start someplace. And Jell-O started here.

In 1897, a LeRoy resident named Pearle Bixby Wait came up with an unflavored gelatin for homemakers to use. (He had purchased the formula from inventor Peter Cooper.) His wife, May, decided they should add a flavoring to it. It was, after all, made of extractions from animal sinew, tissues, and boiled bones. Tough to make that sound "warm and fuzzy."

The first flavors she used were strawberry, raspberry, and orange. Having no luck with the product, the Waits sold their gelatin product to Orator Frank Woodward for $450. He knew a winner when he had it, and the rest is history. The Genesee Pure Food Company sold its first box in 1900. Today Jell-O is the generic name for all flavored gelatins. Millions of boxes of the jiggly dessert are sold every day around the world.

There is a Jell-O Museum and Gallery in Le Roy today. It is located right behind the Le Roy Historical Society building at 23 East Main Street. You get from one building to the other by walking down the "Jell-O Brick Road," a walkway decorated with bricks painted in the colors of Jell-O flavors. The museum is fun and interesting and tells the incredible story of the success of those little boxes of Jell-O (from such humble beginnings).

Years ago it was rumored that scientists found that the inside of a Jell-O dessert mold exhibited electrical pulses similar to those of the human brain. In the museum, be sure and see the brain mold with the electromagnetic probes stuck into it. And watch the needle go!

The museum has perhaps the best gift shop of any museum in Upstate New York.

Jell-O Museum: www.jellogallery.org

LILY DALE ASSEMBLY, CHAUTAUQUA COUNTY

"WORLD'S LARGEST CENTER FOR THE RELIGION OF SPIRITUALISM"

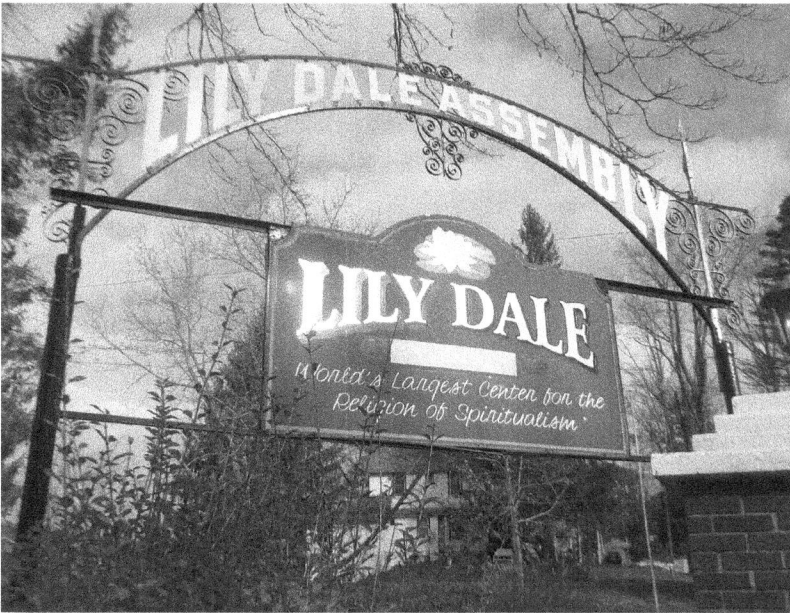

Without a doubt, if you are looking for a unique and fascinating place to visit Upstate, put Lily Dale on your list. Even better, put Lily Dale at the top of your list.

This tiny map dot is located between Jamestown and Buffalo on Cassadga Lake in Chautauqua County. The assembly, incorporated in 1879, counts about 300 permanent residents. Long a center for spiritual connectiveness, the "assembly" hosts dozens of palm readers, psychics, mediums, tarot card readers, seers, and more each year. More than 20,000 visitors come to Lily Dale each year.

A walk around the 140-acre assembly gives one the feeling of being in a "spiritual theme park." The small paths and tight roadways are lined with tall shade trees, some 400 years old. The houses, numbering around 175, are lined up like a chorus line of Victorian-era dollhouses. Each one is painted a different color, most sport attractive front porches and verandas, and well-tended gardens are the norm. Clever signs welcome you to enter and have a "session" with the medium, appointment or not. Many of the residents get around "the Dale" by golf cart in the summer months.

The hamlet is located in the midst of one of the most important old growth forests in western New York and is quite beautiful in all seasons.

In the summer season, a visitor can find any number of things to do here, including lectures, workshops, seances, book readings, healing services, and community events. Lily Dale has its own post office, eating places, and volunteer fire department; and it contains two hotels, guest houses, Spiritualist and New Age bookstores, two eateries, and a café. A lakefront beach and swimming area is also located on the grounds. There is an interesting Lily Dale Museum located within a renovated schoolhouse building that features exhibits on the history of Spiritualism

One word of caution when visiting Lily Dale: Because of the huge influx of people in the summertime, there is an admission charge to enter the grounds. At other times, the front entrance is open without charge.

Lily Dale Assembly website; www.lilydaleassembly.org

34

MARATHON, CORTLAND COUNTY

"HOME OF THE CENTRAL NEW YORK MAPLE FESTIVAL"

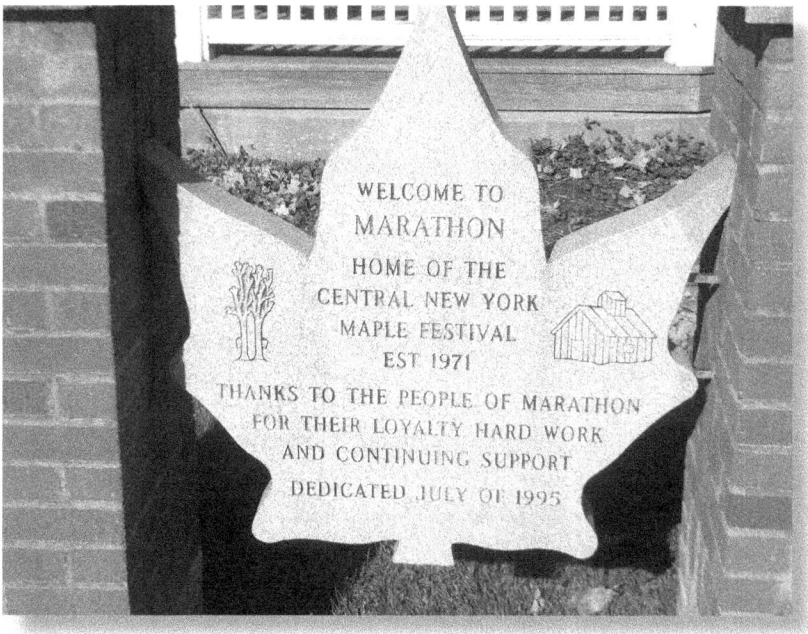

Maple syrup production is big business in New York State. In fact, the Empire State, with almost a third of a million gallons harvested annually, ranks second only to Vermont in total maple syrup production in the

United States. The industry employs thousands of workers across Upstate New York, from small hobby tree farmers to large corporate manufacturers.

Tapping the famed maple trees of our region is hard work but is also an iconic harbinger of spring. When the sap is running and the smoke is billowing from the sap houses, you know that winter will soon be in the rearview mirror.

There are many festivals across the state that celebrate the maple industry. One of the largest is in Marathon, in central New York. The village only has about 2,000 residents, and almost to a man (and woman) everybody pitches in to welcome thousands to the annual rite of spring in the village. At the festival, which is a major fundraiser for the village's nonprofits and school groups, you can enjoy a unique menu of homemade maple-flavored items that you may have never even heard of before. Maple lollipops, anybody? No? How about some maple cotton candy? You get the idea.

Dozens of local producers come to vend the results of their hard work. Visitors can take home all sizes of maple syrup from these vendors, which sell their products in everything from a small souvenir half-pint for about ten dollars all the way up to a gallon jug of the stuff for about fifty dollars. If the weather is good and the crowd is big, you can expect each of these vendors to sell out.

Along with every imaginable maple-flavored food item (yes, pancakes will be served), the festival features dozens of central New York's finest craftsmen selling their items (it is a juried competition), a tour of a one-room school house, helicopter rides, horse-drawn wagon rides, a quilt show, a chainsaw carving, maple syrup–making demos, a mountain men encampment, a book sale, a parade, a maple museum, a pancake-eating contest, face painting, maple munchies, sidewalk entertainment, great food, and much more.

In recent years, motor coach companies from all around the Northeast have put the Central New York Maple Festival on their list of autumn trips. This has almost guaranteed that thousands will attend each year.

Traditionally, parking and admission to the festival are free.

There are several signs welcoming people to this small village, which sits cheek to cheek with the busy north-south Interstate 81 and is halfway between Binghamton and Syracuse. All of the signs mention the maple festival. We like this one the best. A giant gray stone carved in the shape of a maple leaf. Perfect.

CNY Maple Festival website: http://www.maplefestival.org/

MOUNT MORRIS, LIVINGSTON COUNTY

"HOME OF THE PLEDGE OF ALLEGIANCE"

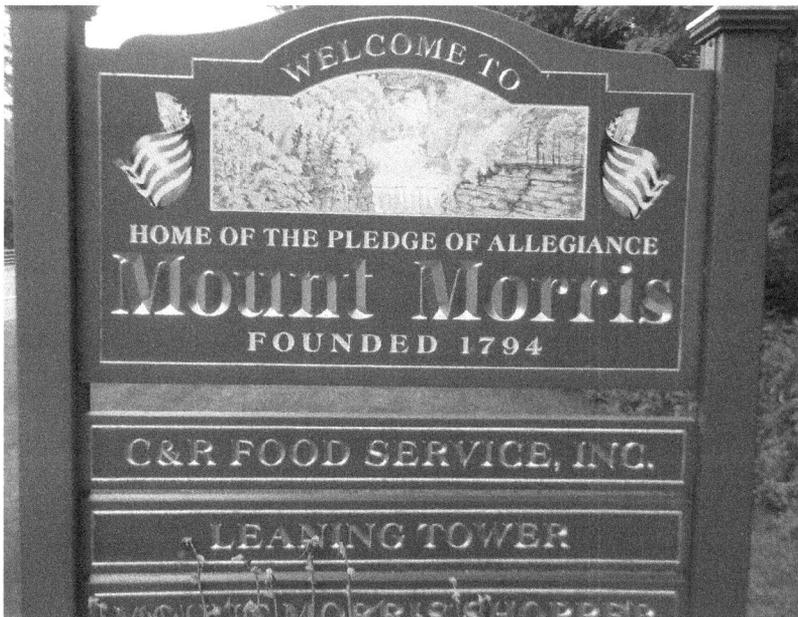

As a writer of many Upstate New York books, and having done several hundred talks and live presentations, I am a firm believer that every town or village, no matter the size, is famous for something. Anything. And when that "something" is discovered in the town's DNA, I always advocate that the community put that information up on its welcome sign. I reason that

this might well snare people passing through (like me) to stop, look around, and maybe ask a question or two. In fact, that is the reason for this book.

So it is always interesting when, maybe for lack of other historical footnotes, several places put up signs that state they are the "birthplace" of someone or something. No matter how fleeting that historical connection may be. And that is fine with me.

Mount Morris is like that. Heralding itself as the "Home of the Pledge of Allegiance," we can dig deeper and find that what that really means is that the author of the Pledge, Francis Bellamy, was born in this village on May 18, 1855. He didn't stick around long; in fact, the family moved to Rochester when he was barely five years old. Yet his birthright claim to Mount Morris apparently is good enough to get that information written in gold on the town's welcome sign.

And, as I said, that is fine with me.

An 1888 magazine, *Youth's Companion*, was seeking a way to sell more American flags to public schools when it hired Francis Bellamy to write an ode to America that would help celebrate the 400th anniversary of Christopher Columbus's discovery of America in 1492. In 1892, the Pledge, as we know it, was printed in the magazine. In 1942, the US Congress formally adopted it as the nation's official pledge. There have been ever-so-slight changes since Bellamy wrote the pledge, including President Eisenhower's famous adding of the words "under God" in 1954.

Today, Mount Morris remembers its famous but oh-so-brief native son in many ways. The house he was born in has a historical marker in front of it, and there is a dazzling and massive wall mural on display in the downtown area filled with patriotic icons and the story (in images) of Bellamy's contribution to the American scene.

Mount Morris sits on the edge of the greatly popular Letchworth State Park, and no doubt many people pass this featured chapter sign on their way to a vacation without realizing the town's fame.

Mount Morris (with photos of the mural): https://www.facebook.com/MountMorrisNY/

36

NORTH TONAWANDA, NIAGARA COUNTY

"HOME OF THE CARROUSEL"

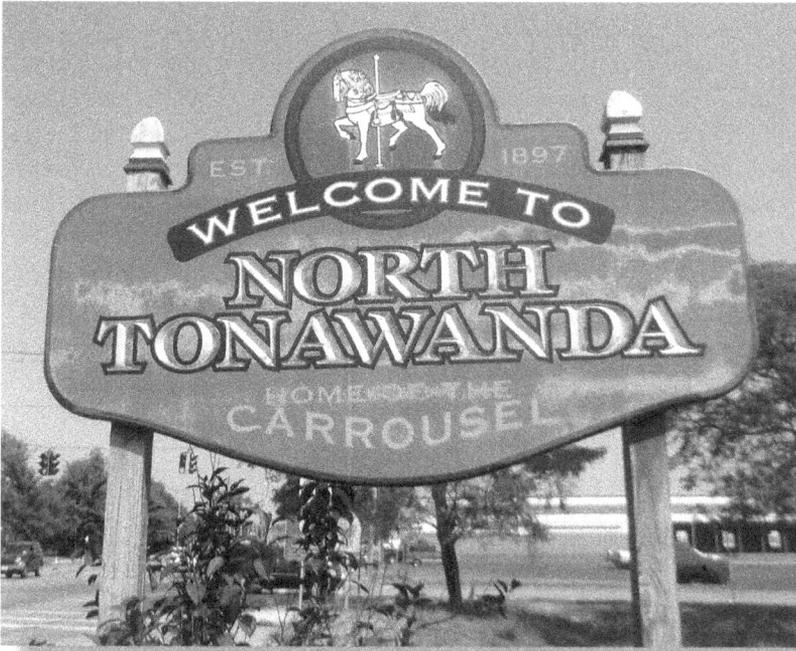

While there are a few other welcome signs in this book that you might want to have your kids keep their eyes open for, this is certainly the best.

Allan Herschell was the preeminent carousel maker in the United States. His factory was located here in North Tonawanda. It was built between 1019 and 1915.

That is the adult part.

Today the Herschell Carrousel Factory is alive and welcomes families and children of all ages to see the factory floor, look at the whimsical items for sale in the gift shop, and yes, even take a ride on one of the several carousels in operation on the grounds.

That is the kid part!

The factory museum is located in a residential area just a few blocks from the North Tonawanda business district. There is a kiddie playland with several smaller carousels and rides to enjoy, and inside is the big one. A historic, fully operational 102-year-old Herschell original carousel. The carvings and colors are spectacular; the hundreds of blinking, colored lights add to the midway effect; and the sounds of the three old Wurlitzer organs blasting away with carnival music are the perfect topper to a perfect family museum experience.

To settle a question I see coming, yes, they do spell the word with two r's here. It is an old usage, and today it is hardly seen any more. Currently you will either find "carousel" or, even more likely, the word "merry-go-round" for the ride. But in keeping the historic importance of this factory museum, they continue to use the odd-looking but oh-so-proper spelling of carrousel. As was first used by Allan Herschell himself

The Herschell Carrousel Factory Museum is located at 180 Thompson Street, Lackawanna, NY 14121.

Website: www.carrouselmuseum.org

37

PHELPS,
ONTARIO COUNTY

"HOME OF THE SAUERKRAUT WEEKEND"

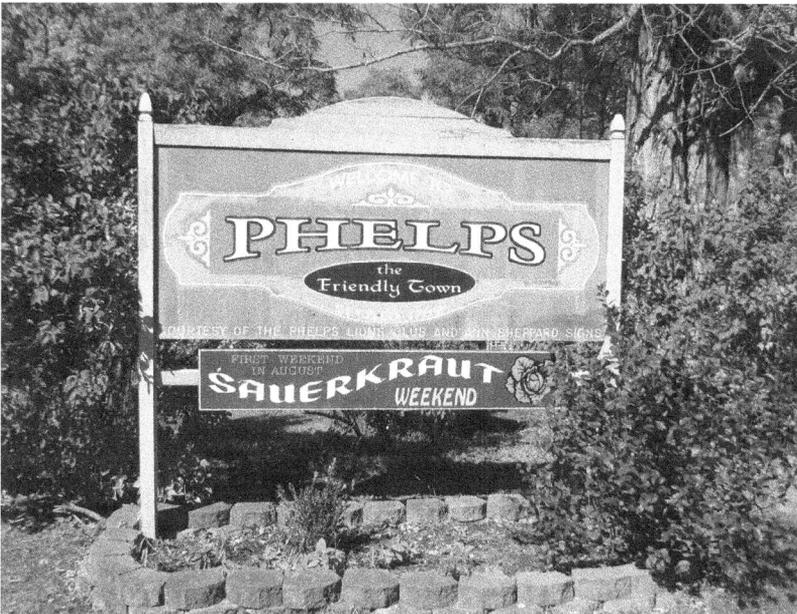

Upstate New York hosts a cornucopia of historic growing areas. Many of them are included in this book. We grow everything from award-winning grapes, to some of the best apples in the Northeast, to fields of sweet corn as far as the eye can see, to the famous black dirt onions of the lower Hudson Valley, to the bounty that springs from the fertile farmlands in

Schoharie County, which George Washington called "The Breadbasket of the Revolution."

So what's up with sauerkraut? I mean other than putting it on a hot dog or Reuben sandwich, who ever gives this fermented cabbage a thought?

They do in Phelps.

For decades this village was considered the "Sauerkraut Capital of the World." Farmers grew hundreds of tons of cabbage, and there were several large processing plants here that produced fully one-third of the sauerkraut consumed in the United States.

The largest of these manufacturing plants was the Silver Floss Foods Company. That company as well as the Seneca Sauerkraut plant employed hundreds of locals down through the generations. Both companies left Phelps long ago, in the 1980s and 1990s.

It seems that during a particularly difficult period for the Silver Floss company, the community rallied to its support and organized a Sauerkraut Weekend in 1967. And it continues today on the first weekend in August.

People gather for cabbage-head decorating, sauerkraut-eating contests, cabbage bowling, cabbage recipe swaps, and a parade that crowned a King and Kween Kraut. The festival continues to this day on the first weekend in August. A highlight of the festival is the Krauter 20k running road race. It is the oldest race of its kind in the Finger Lakes.

When attending the Sauerkraut Festival, be sure and stop by the Howe House Museum at 66 Main Street. This historical society property is in a beautiful brick home with one unusual, distinctive feature: a two-story outhouse. It is attached to the back of the 1869 Second Empire–style home and is the only two-story brick privy in the United States. And for the curious, it is a six-holer. Three up and three down.

Phelps Sauerkraut Weekend: https://www.phelpsny.com/sauerkraut-weekend/

38

PINE ISLAND, ORANGE COUNTY

"HEART OF THE BLACK DIRT REGION"

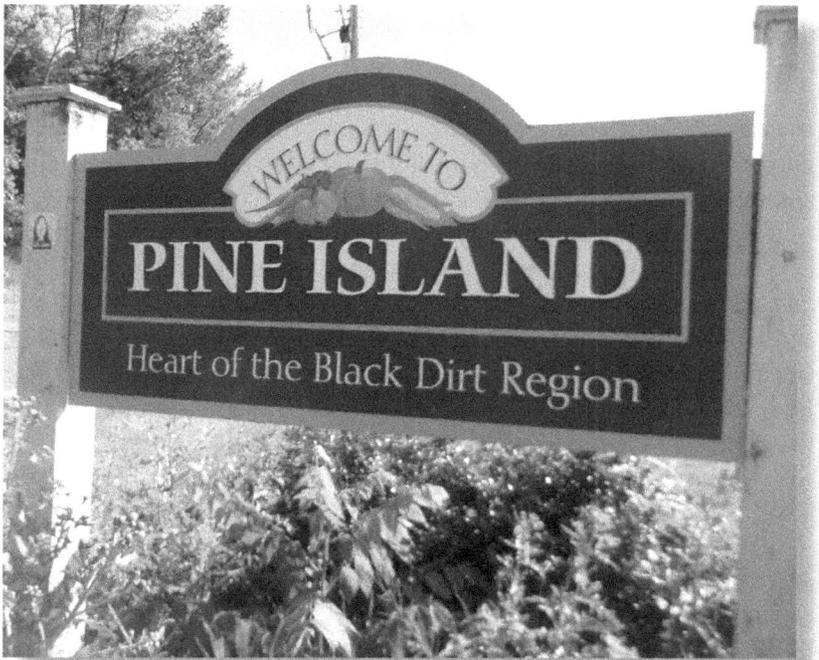

I have visited and researched this region for a number of years, and just prior to publishing this book, I took a journey back to this southern New York region, which borders New Jersey. Just to refresh my memories.

Yup, it is still there. You smell it first.

Just a hint of onion in the air as you slope down from the surrounding hillsides to a flat plain that stretches as far as the eye can see. During the spring growing season, the nickname for this community becomes obvious immediately.

The soil, thousands of acres of it, is as black as night. It looks as if the land is covered in black coffee grounds, and for rows and rows, in fact miles of rows, you can see millions of onions being nourished in this black soil. This is where some of the best onions in the world were once grown.

Pine Island, and another half-dozen neighboring towns, was once known as the "Onion Capital of the World." I say "was" because the onion harvests are smaller now than, say, a century ago because of changing tastes, scientific innovation in the agri-world, and imports from around the world. But onions are still the mainstay in this region, along with potatoes and other basic vegetable crops.

The rare black soil is a remnant of the glacial period and is a product of near-constant flooding by nearby regions. The "muck soil" is rich in nutrients and is a reliable commodity thanks to creative drainage, ditch and canal troughs, and proper soil management.

To see the "black dirt region" in all its glory, during growing season, is to see one of the most unusual farmland sights in the Empire State. The area covers more than 25,000 acres, and there are any number of farms, and farm stands, where you can stop at and see this rare phenomenon. One of the largest and oldest produce farms is the A. Gurda farm in Pine Island. The family's Polish immigrant forefathers began working the land five generations ago.

Go visit, stop and take a look, take a whiff of the air, and bring home a bag of some of the best onions in the world.

There are three interesting factoids I like about this region. First of all—where is the "island" in Pine Island? The name comes from the days when this area was covered with flood waters and these little parts of land, like Pine Island, would stick up as dry, well, islands. The area was known informally for years as the "Drowned Lands."

And if you are jealous of this region for having such luck with their green thumbs, do not try and scoop up some of this fertile dirt to take back to your own garden. It is illegal to do so.

Also, for many years there was an interesting piece of information making the rounds that trivia buffs loved. It was said that the black dirt region of Orange County, New York, when freshly plowed and ready to plant, could actually be seen, like a "black scar across the green land," by the naked eye from outer space. True?

I'll let you know the next time I am in outer space.

Black Dirt Region history: https://www.pineislandny.com/black-dirt-region/

39

PORT HENRY,
ESSEX COUNTY

"CHAMP SIGHTINGS IN BULWAGGA BAY AREA"

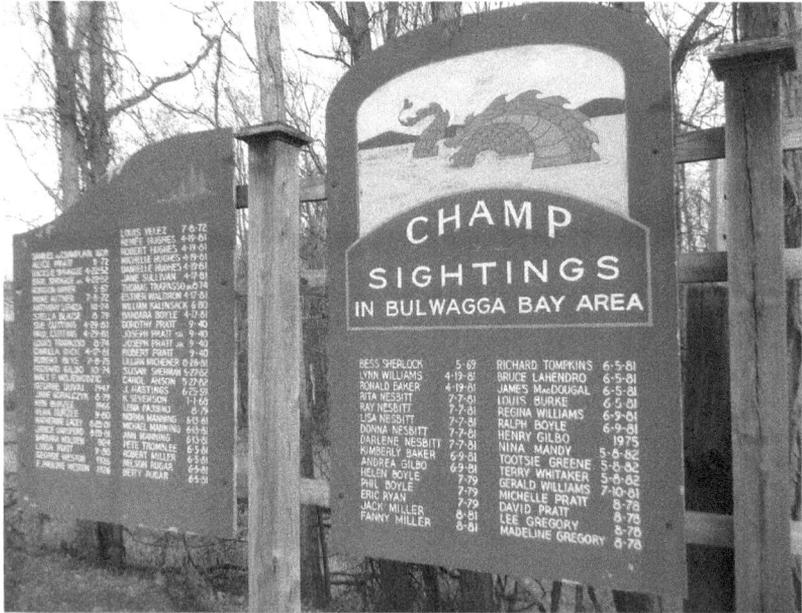

OK, so this legend supposedly goes back to French explorer Samuel de Champlain, the first European to set his sights on Lake Champlain in northern New York. During his explorations, de Champlain reportedly noted the presence in the lake of a monster "fish" that was twenty feet long and had the head of a horse. Well, that was all it took.

Nicknamed "Champ," there have been literally hundreds of "sightings" of this friendly lake monster over the centuries. Here in Port Henry, there is a large welcome sign that puts all the data out for everybody to see. The sign, actually a series of billboard-sized signs, lists hundreds of reported Champ sightings, giving the name of the person who claimed to see him and the year of the sighting. It is quite a remarkable piece of public data, and tourists stop and take a look at it frequently. And yes, the very first name on the sign is explorer de Champlain.

With the sign numbering hundreds of names, Port Henry can be somewhat of a "Gateway to Champ sightings" in the area. It is said that the hamlet's fishing bay, Bulwagga Bay, is really the watery home of Champ.

Champ has turned into an economic juggernaut for the area, with his image re-created on everything from posters to statues to plush animals to car decals. Across the water, in Burlington, Vermont, they named their minor league baseball team (NY-Penn League) the Lake Monsters, and you can only imagine what the team mascot looks like.

Paranormal hunters have scoured the area, television's Discovery Channel has come to take a look around, and people from this tiny lakeside community all the way up to the city of Plattsburgh hope to catch a glimpse of the sea monster and then get their name on the Champ honor roll at the outskirts of Port Henry, New York.

A travel suggestion: If you are coming up to Port Henry to find out more about Champ, you really should try and come for the annual Champ Day–Lake Monster Festival held every summer. The whole community gets involved in a fun celebration of their favorite sea serpent, which is held at (naturally) Champ Beach Park.

Champ Festival: https://www.porthenrymoriah.com/events-0

40

ROSCOE, SULLIVAN COUNTY

"TROUT TOWN U.S.A."

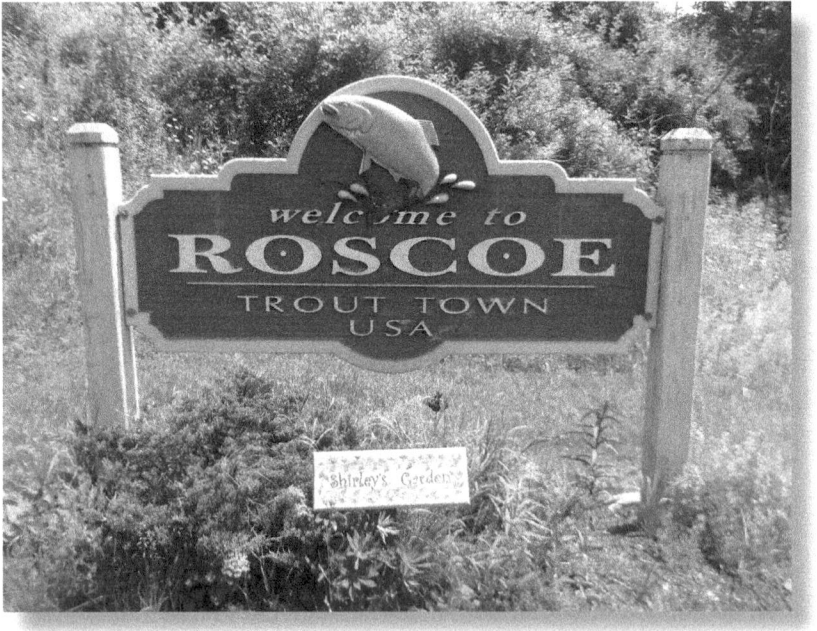

There is a better chance than not that when you drive into Roscoe before or after winter, you will see the iconic image of a solitary person, alone and focused, standing knee-deep in the middle of any fog-covered river or creek, waterproof pants up to his chest, a wicker creel slung over his neck, and wearing a crushed hat covered with elaborate fishing ties. He (or she)

is alone, one with the river, casting his line far and wide out before him. Watching and listening, tugging on the rod, hoping this is the big one.

Fly-fishing is second nature in Roscoe. It is a legendary place where thousands of anglers from all over the world come to cast a line and try their luck. The famously trout-rich Willowemoc and the Beaverkill offer an irresistible siren's call to these fish fanatics, one that is hard to ignore. Cars along the small business district sport license plates from all over the Northeast, and beyond.

Roscoe is proud of its nickname, "Trout Town U.S.A.," but it would also be comfortable if it were known as the "Birthplace of Fly Fishing in America." You can't escape the notion. Colorful trout jump out at you from storefront signs, on the pages of coffee-shop menus, on the fronts and backs of numerous T-shirts, and on the blue and white lamp post banners that read "Trout Town Proud."

Celebrities from the worlds of sports, politics, and Hollywood are often seen in the river or in the sporting goods shops along Main Street. The actor Mark Ruffalo, who lives nearby, is a regular. President Jimmy Carter came and called this one of his favorite fishing places in America.

Just four miles south of the hamlet you will find the Catskill Fly Fishing Museum and Hall of Fame. Among the many inductees are Paul Young, who created a revolution in the sport with his historic 1926 bamboo rods; Joe Brooks, the legendary outdoor sports writer who fished the four corners of the world; Frederick Halford, considered to be the "Father of Dry Fly Fishing," and actor Robert Redford, whose 1992 film classic *A River Runs Through It* did more for the sport of fly-fishing than any other event.

If you get hungry after a day of fishing in the cold river, warm up with a hot meal at the Roscoe Diner. Opened in 1969, it has been called "Upstate's Most Famous Diner" and sees hundreds of thousands of customers each year.

And if you get thirsty and are in the mood to kick back with your buddies and tell a few fish tales, there is a popular craft brewery in town too. It is called (of course) Trout Town Brewery.

Catskill Fly Fishing Museum and Hall of Fame https://cffcm.com/

41

SENECA FALLS, SENECA COUNTY

"BIRTHPLACE OF THE WOMEN'S RIGHTS MOVEMENT"

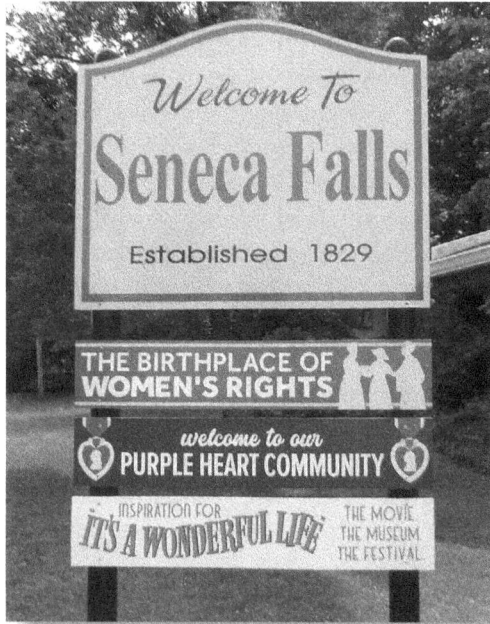

This village of about 9,000 residents is one of Upstate's most historic small towns. In July of 1848, a large group of women came to this Seneca County village to hold a convention laying out a template for the first women's rights goals in the country. It was the first convention to be organized, led, and attended (mostly) by women. The women met "to discuss the social,

civil, and religious condition and rights of women" in the United States. Many of the great female icons of the day attended.

Today, the National Women's Rights Historical Park attracts thousands of visitors annually. There is much to see here, including a wonderful museum to the birth of the women's rights movement, plus the National Women's Hall of Fame. Remnants of the historic Wesleyan Chapel, where the convention was held in 1848, can still be seen.

If you look closely at the Seneca Falls welcome sign, you can see the image of three women in white silhouette. This is in reference to one of the village's most famous statues. The life-size triple statue depicts the first meeting on the streets of Seneca Falls on May 12, 1851, between three of the era's most prominent women activists: Susan B. Anthony, Elizabeth Cady Stanton, and Amelia Bloomer.

The Cayuga-Seneca Canal, completed in 1818 (before the Erie Canal), offers a placid backdrop to the important village.

On another note, movie fans come to the village in increasing numbers to enjoy the charming *It's a Wonderful Life* Museum. The 1946 movie, always ranked as one of the top-five most beloved Hollywood films, had a beginning of sorts in Seneca Falls. The museum documents director Frank Capra's visit to the village while he was preparing to produce the movie. Capra had many family members in the surrounding area and was charmed by the small-town feel of the village. Is Seneca Falls the inspiration for the film's Bedford Falls? Well, the museum makes a pretty compelling case for just that.

The *It's a Wonderful Life* festival is popular with movie fans, who attend every year. Several of the cast members—the young ones who played the children of Donna Reed and Jimmy Stewart in the film—regularly attend the festivities.

Women's Rights Historical Sites: https://freethought-trail.org/
It's a Wonderful Life Museum: https://www.wonderfullifemuseum.com/

42

SHERRILL,
ONEIDA COUNTY

"THE SILVER CITY"
"THE SMALLEST CITY IN NEW YORK STATE"

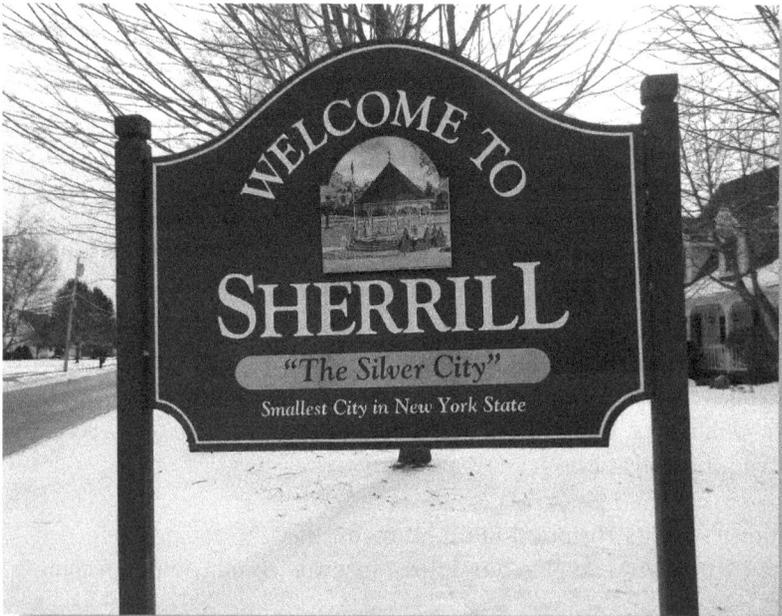

OK. The "Silver City" first.

Oneida Limited was founded here in 1880. The Noyes Utopian Community had a huge manor house here (still standing), and even though their

concept of a "free love Perfectionist society," a term coined by sect founder John Humphrey Noyes, was short-lived, from 1848 to 1880, it eventually did burn out. The community then fashioned itself into a manufacturing company led by John Noyes's son, Pierrepont. It was a silver manufacturing company called Oneida Limited, a silver service creator that eventually became heralded for making the finest silverware and stainless-steel flatware in the world.

Today, the Sherrill Manufacturing Company, which bought out Oneida Limited in 2006, remains the only flatware manufacturer in the United States.

The mansion, known as the Oneida Community Mansion House, is an amazing place, filled with a warren of small "apartments" used by the community's members more than a century ago, as well as huge meeting rooms, concert halls, a library, a gathering room, and a kitchen. And you can tour it today. It is said that when it was built, it was erected using millions of red bricks.

John Humphrey Noyes is buried behind the mansion, near the golf course, in the Oneida Community Cemetery, where he is surrounded by the graves of some of his followers.

Now, let's talk about the "smallest city" part of the welcome sign. It is a bit tricky.

For some weird reason, when Sherrill was founded in 1916, it was declared a city, and thus they created a city charter. However, they then inserted language into the law stating that although Sherrill was in fact a city, it would be forever treated as if it were a village, located within the town of Vernon. The reasons for this were many, but frankly they have been lost in antiquity. It is the only city in New York State to have such an unusual arrangement.

So, with a population of just about 3,000, Sherril comes in dead last on all New York State city population lists. And therefore it gets the honor of having a mention on the village's, um, I mean the city's welcome sign.

Sherrill is located four miles south of the sprawling Turning Stone Resort and Casino.

Oneida Community Mansion House: https://www.oneidacommunity.org/our-history

43

TOWN OF SPRINGFIELD, OTSEGO COUNTY

"THE PLACE TO BE ON THE 4TH OF JULY SINCE 1914"

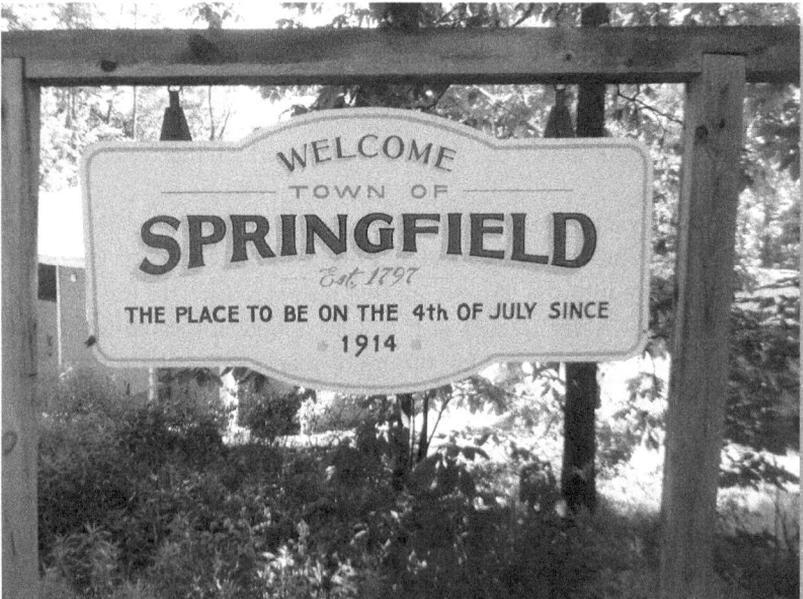

The whole purpose of this book is to encourage communities all across the state to be proud of their history and to put it out there where everybody can see. Meaning, put it on the town's welcome sign.

There are many people like me—call us history nerds if you wish—who like nothing more than going on a carefree drive along a backroad in, say, Upstate New York, just looking for adventure. Of course, we have no way of knowing the history about the little towns we travel through without stopping and Googling it. But the welcome sign can be the first tip-off of something cool and interesting ahead.

For this writer, it would be impossible for me to drive through a place called "Book Village of the Catskills," "The Silver City," or even "Birthplace of Elsie the Cow" without stopping, asking, looking around, and finding the meaning of the welcome sign. Some welcome signs carry a lot of heft, like "Birthplace of the American Navy," or even "Home of the Winter Olympics of 1932 and 1980," but others are a little less significant. No less interesting, for sure, but a little under the radar. Nevertheless, I am still compelled to pull over at places that tell us "Birthplace of Jell-O" or "Home of the Famous Black Dirt Onions."

Yup, I am stopping.

Which takes us to little Springfield, New York, in Otsego County. It lies on the western side of Lake Otsego ten miles north of Cooperstown. It is a classic drive-through map dot. Pretty houses, a small country store, some historic buildings and churches, a couple of craft and antique shops, and little else. But it does have a claim to fame, and, thankfully, they put it right out there on their welcome sign.

Springfield Center, with a population of just over 1,000 residents, is home to the oldest Fourth of July parade in New York State and certainly one of the oldest in the nation (nobody will ever touch Bristol, Rhode Island's Ruthian statistic of more than two centuries of this parade). These things get a little murky in the details. Was the parade held consecutively? Is there a clear record of when it started, or just local lore? It is certain that the parade here has been held every year since 1914. No question. (Of course, every place gets a pass for 2020, the "Year of the Great Pause.")

On Independence Day you will find Springfield's Main Street (Rt. 80) packed with thousands of people waving American flags, cheering on the parade units, and having a good old American family celebration. The parade is long and colorful. It is filled with shiny fire trucks from a wide area of neighboring towns, marching bands, youth groups, dance units, and smiling, waving politicians riding in old antique cars. A tall, stilted Uncle Sam usually leads the way. The parade is followed by festive events

including live music presentations and plenty of delicious food. The whole town is drenched in a patina of red-white-and-blue on this day!

So, is it a big deal in the scheme of New York history? No. But it is a big deal here; it is a warm tradition for generations of central New Yorkers and, in our opinion, the perfect example of what this book is all about.

Good job, Springfield. God bless America! And . . . see you on July 4!

Springfield July 4th Parade: https://www.facebook.com/SpringfieldParade/

44

TROY,
RENSSELAER COUNTY

"HOME OF THE BURDEN WATER WHEEL"

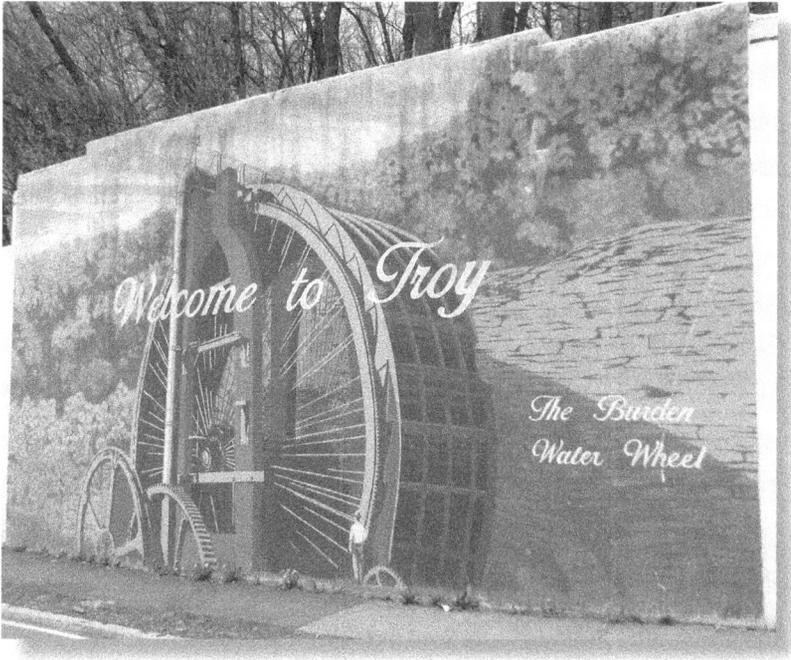

I was torn about which welcome sign for the city of Troy to include in this book. There are several. Most predominant are the signs welcoming you to the "Home of Uncle Sam." But I thought that was a little too well-known. Almost everybody, even schoolkids, learns that the iconic character of Uncle Sam, with his wispy white beard and red-white-and-blue hat and

jacket, is perhaps the most popular personification of the United States, and was actually patterned after a meat packer in Troy.

Samuel Wilson marked his barrels of dried meat heading off to the American Army during the War of 1812 with a bold "U.S." That simple two-letter insignia soon became known as the mark of Uncle Sam of Troy, and a legend was born. The real Samuel Wilson ("Uncle Sam") is buried in Troy, and his grave is one of the most visited sites in the city.

The name Uncle Sam appears all over Troy on signs, business store-fronts, parks, banners, and more. But there is another welcome sign that I like even better. As you travel up through the south end of Troy into the city you will see a massive, full-color mural on a tall highway underpass. It depicts the famed Burden Iron Works water wheel welcoming you to Troy.

In the early 1800s, Henry Burden used water power to make nails, horseshoes, and other items at his big iron works factory along the Hudson River. To do this, he created some of the largest "water wheels" anybody had ever seen. The spinning wheels, laden with water, would spin and spin up in the hillsides, bringing huge amounts of power down the slopes to his factory. The largest one he made was historic.

In the early 1840s, Burden built the largest water wheel the world had ever seen. It was sixty feet in diameter and had thirty-six large buckets, each twenty-two feet across and six feet deep. Near Burden's factory was the Wynantskill Creek, which he dammed up creating a man-made reservoir. That is where he placed his gigantic water wheel. Once the water was released, the wheel buckets would fill and carry the wheel around twice per minute. This was all the power Burden needed to bend the nails and make the horseshoes (millions of them) he sold and provided to the public as well as to the US Army.

It is said that an engineer and inventor named George Ferris, who had studied at Troy's Rensselaer Polytechnic Institute, had seen the Burden water wheel as a student and used it to invent his most famous creation, the Ferris wheel.

The color depiction of the wheel on the mural, with the image of Henry Burden placed in front of it to show in perspective how large it was, is one of the best welcome signs in this book.

Unfortunately, nothing remains today of this historic achievement.

Visit the Burden Iron Works Museum to learn more about it at www.hudson mohawkgateway.org.

45

UNADILLA, OTSEGO COUNTY

"BOYS SCOUTS OF AMERICA: HOME OF TROOP #1"

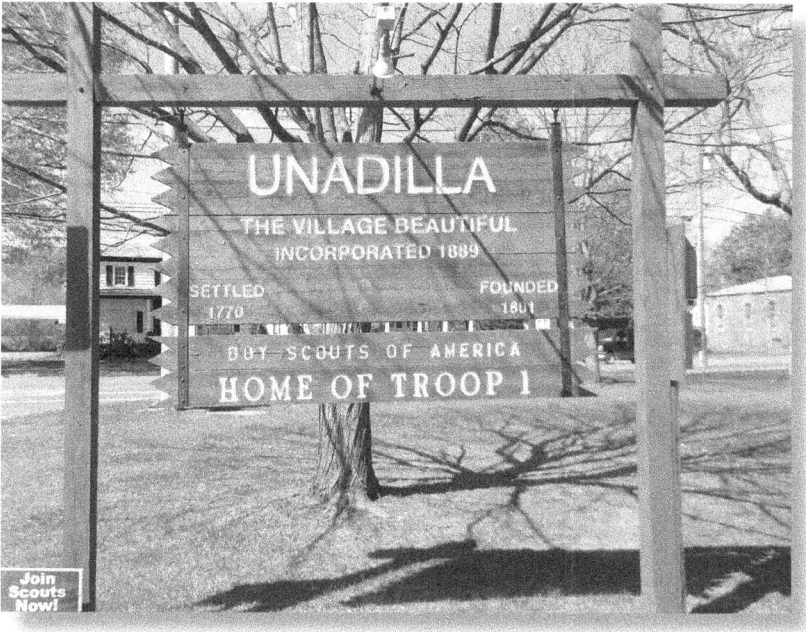

Unadilla, a village of about 4,000, sits on the banks of the Susquehanna River in the lower southwestern corner of Otsego County. Known far and wide as "The Village Beautiful," Unadilla holds a special place in Boy Scout lore.

Sir Robert Baden-Powell started the scouting movement in his home country of England. It was a success. He held his first Scout Rally at the famed Crystal Palace in London's Hyde Park in 1909. Soon the youth movement took root in America.

In Unadilla, the Rev. Yale Lyon formed a small Boy Scout troop with about thirteen members shortly thereafter. Clearly, this would not be the first Boy Scout troop in the United States or the only one given the title of #1. In fact, more than 4,000 troops carried that honor. Unadilla's was 166th in line.

But over the last century or so all of the other troops have either disbanded, merged with other troops, or just vanished because of a lack of members. Unadilla holds the distinction of being the lone Troop #1 that has been continually chartered since its inception more than 100 years ago. Now given the honorary title of "America's Centennial Troop," the Boy Scout troop in this little village is proud of its unique distinction.

In fact, banners hanging from the light poles along Main Street shout it out for all to see, declaring the village to be "Home of Boy Scout Troop #1."

The official welcome sign for the village reads the same way.

There is a Boy Scout Museum in Unadilla that holds a whole treasure trove of scouting memorabilia dating back to the troop's origin. Archival photographs, scouting ephemera, vintage uniforms, Rev. Lyon items, merit badges, camping manuals, and other mementos line two walls of the old Masonic Temple on Main Street.

The beloved Rev. Yale Lyon is buried in the St. Matthews Episcopal Church cemetery behind the museum. He was the rector of the church for more than three decades. A small plaque on his grave identifies it as a "Boy Scout Historic Site."

The village holds another interesting distinction that is similar to the aforementioned Springfield, New York. Unadilla holds the longest continuously running Flag Day parade in the United States. It began in 1951.

Now if only it would put that little tidbit on its welcome sign too.

Unadilla Boy Scout Museum
131 Main Street
Unadilla, NY 13849

Website: http://trp1bsaunadillanyhist.blogspot.com/

46

UPPER JAY,
ESSEX COUNTY

"HOME OF TOY MAKER ARTO MONACO"

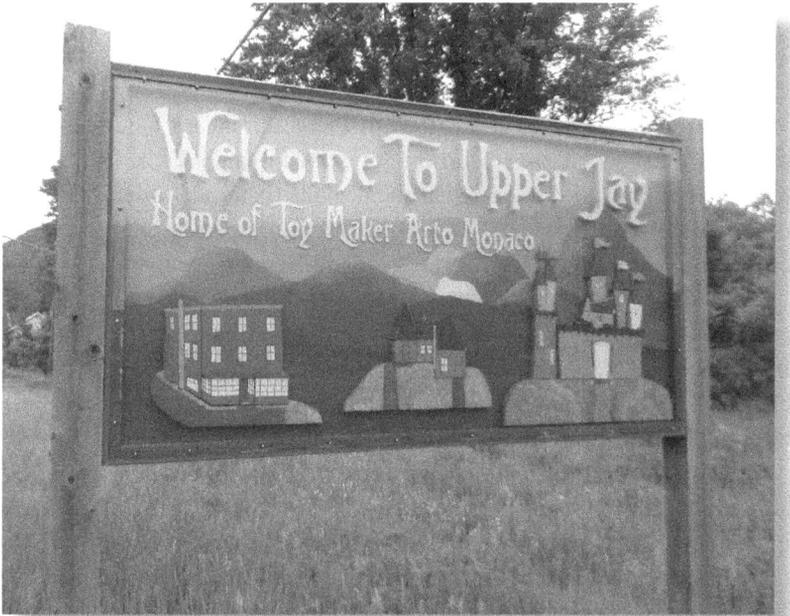

For New Yorkers of the Baby Boom, the Adirondacks were a summer destination known as "Vacationland." It was a magical place of small mom-and-pop motels, of swimming in clear mountain lakes, of hot dog stands and ice cream parlors, of walking the glitzy streets of Lake George at night, and of playing some amazing miniature golf.

A region dotted with small, family-friendly amusement parks with various whimsical themes, it was also the most unusual place a kid could imagine. And these were some of the first theme parks in the country.

In the 1950s you could stalk bad guys with the sheriff at Frontier Town (and take home a tin deputy sheriff badge for your efforts). You could watch Jack and Jill slowly head to the top of the hill to fetch a pail of water, only to come tumbling down again, hour after hour, week after week, year after year, like a Sisyphean pageant of frustration ripped from the pages of our children's books, over in Storytown U.S.A.

You could drive your first car! It was a mini gas-powered roadster that you could drive without mom and dad helping you. Thank you, Gaslight Village. You could feed the live reindeer and then cheer lustily as Mr. and Mrs. Claus came out for their hourly parade at Santa's Workshop North Pole (even though it was eighty-five degrees out). And you would wait patiently for Rapunzel to let down her hair for the dashing prince to climb up to kiss her in a place called Land of Makebelieve.

Arto Monaco was born and died in these Adirondack Mountains. He was the genius behind many of these "preserved in amber" theme parks of the 1950s and 1960s. He designed them, built them, and nurtured them until Mother Nature wiped several of them out in flooding. Monaco was a genius illustrator, toy maker, cartoonist, and businessman.

At the time of his youth, the Adirondacks were filled with famous people. Artist Rockwell Kent lived here and helped Monaco get into Pratt Institute in 1937. John Steinbeck wrote over here, singer Kate Smith broadcast her radio show over there, Oscar-winning director Lewis Milestone lived in the next town over.

Arto Monaco lived a life surrounded by celebrities. He worked as a set designer for all the major movie studios in the Golden Age of Hollywood, including MGM, Disney, Paramount, and Warner Brothers.

His toy-making abilities did not go unnoticed, and he worked for Ideal Toys, Hasbro, and Mattel for many years. He assisted with the designing of Disneyland in Anaheim, California.

When he moved back to the mountains, he was at the peak of his output. Arto designed Santa's Workshop, North Pole Park in Wilmington, New York. It opened in 1949. Next up was Old MacDonald's Farm in Lake Placid. Then came Storytown, Ghost Town, and Frontier Town, much of which still exists in the Great Escape Water Park south of Lake George.

Arto designed and ran the Land of MakeBelieve. It opened in 1953 in Upper Jay, New York. The park closed in 1979 after a flood ravaged the area. While open, it flooded eleven times, with Arto rebuilding it each time until the flood in 1979. He also designed Gaslight Village in Lake George, which opened in 1956.

As a consultant, he continued to spread his fairy dust over the mountains. He advised on the Enchanted Forest Park in Old Forge, as well as being a design consultant at Montreal's Expo 67 World's Fair.

Thank you for the memories, Arto Monaco, the master toy maker and the man who made a lot of our dreams come true when the Adirondacks were known as "Vacationland."

And while we all know and remember the theme parks Arto gave us, what about his toys? This genius gave us the ideas and prototypes for 1960s and 1970s favorites such as the Hungry Hippo, the Original Transformers, and those Rock'em Sock'em Robots.

Adirondack History Museum: Website: https://www.adkhistorycenter.org/jay. html

47

WALLKILL, ULSTER COUNTY

"ELSIE'S BIRTHPLACE"

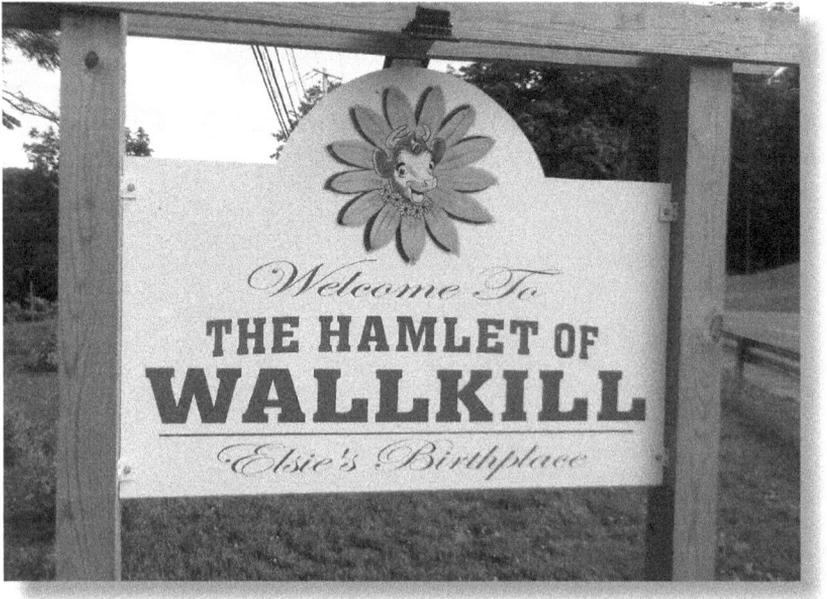

Even though the sign says it is so, there are plenty of people who question that this hamlet was in fact the birthplace of Elsie the Cow, one of advertising's most iconic images.

John Borden, of the Borden family who gave us everything from Elmer's Glue to condensed milk, was the wealthiest man in town and for

good reason. Inheriting the fortune and the company from his father, Gail Borden, John was the first person to mass-produce milk in a glass bottle. But his interests, although far-flung, really centered on this tiny Ulster County community and the Borden Home Farm.

This was John Borden's dream. He wanted to create an idyllic (and massive) working farm that was productive, innovative, and attractive. He wanted his working farm to be a role model for other large, sprawling farms that could "work good and look good." This farm would become the foundation of what is today Wallkill, New York.

By all accounts, the Borden Home Farm was a success. By 1889, the farm was a beehive of activity employing hundreds of workers and consisting of 246 beef cattle, 250 young heifers, 77 milking cows, and more than 1,000 other animals including sheep, hogs, and chickens. The vast expanse of the farm included wheat fields, cornfields, and an apple orchard with almost 700 apple trees. Worker's cottages, barns, equipment sheds and storage facilities were all connected by nearly 400 miles of walking paths over the 1,500 acres.

It is said that in one of the more than 400 barns was a cute little Jersey cow that was John Borden's daughter's favorite. Marion Borden named her Elsie.

By 1938 this little cow had become the iconic figure that represented the Borden company around the world. Her smiling, flower-bedecked face was seen in thousands of magazine and newspaper advertisements.

The sad truth, however, is that there is a real controversy about Elsie's origins.

Perhaps the most durable claim to fame is a cow who was raised in Plainsboro, New Jersey. This "Elsie" was featured at the 1939 World's Fair in New York City, where she and her cow friends demonstrated Borden's revolutionary rotary milking parlor. Tens of thousands of visitors fell in love with her at the fair, cementing her reign as the real Elsie the Cow. The cow's given name was You'll Do Lobella.

Still, Wallkill locals cling to the dusty old memories, handed down over nearly a century, of Marion Borden's favorite little cow named Elsie, a cow destined for stardom.

So, even though Plainsboro claims that Elsie was born and died in its village, Wallkill puts its claim on its hamlet's welcome sign, and that gets it inclusion in this book.

Very little remains of John Borden's dream for his utopian farm. One of the two buildings still standing in Wallkill is Marion Borden's mansion.

You'll Do Lobelia's grave can be found on the Walker-Gordon Dairy Farm in Plainsboro, where she was buried in 1941. It is a popular spot with tourists and visitors in the area. Her tombstone reads: "A Purebred Jersey Cow. One of Great Elsie's of Our Time."

There is no mention of where Marion's "Elsie" is buried. John Borden and his youngest daughter both died at the age of forty-seven.

In 2000, *Ad Age* magazine named Elsie the Cow as one of the top-ten advertising icons of the twentieth century.

Borden Home Farm: https://www.newyorkalmanack.com/2014/07/ulster-county-the-borden-family-of-wallkill/

48

WATERLOO,
SENECA COUNTY

"BIRTHPLACE OF MEMORIAL DAY"

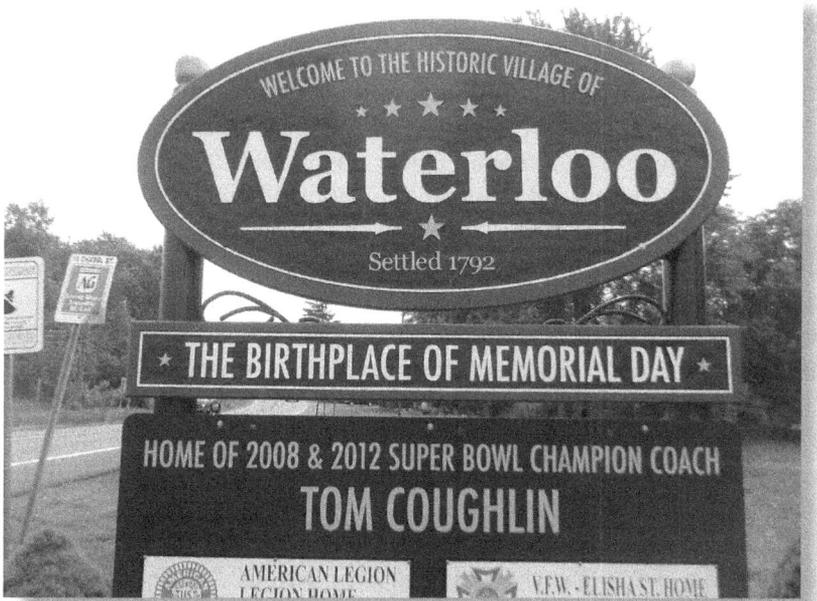

It took a little research and perseverance for the village of Waterloo, New York, to be declared the official birthplace of Memorial Day.

Henry Welles, a local pharmacist, organized a "decoration of graves of the war dead" following the Civil War. He was joined in this effort by General John Murray. Another general, John A. Logan, is considered by

most to be the "Father of Memorial Day," and his "1866 Order of the Day" is still read at many of the day's commemorations around the country.

The first Memorial Day (then called Decoration Day) in Waterloo saw many of the village's residents, dressed in black, walk to the local cemetery where floral tributes were placed at the graves of Civil War (and other) dead. The homes of Waterloo were bedecked with black bunting, and flags were flown at half-staff.

At one time more than two dozen American cities were laying claim to having conducted the first Memorial Day celebration in the United States. These included communities in both the North and the South. Among them were Savannah, Georgia, Warrenton, Virginia, Jackson, Mississippi, Gettysburg, Pennsylvania, and Waterloo, New York.

On March 7, 1966, New York Governor Nelson Rockefeller proclaimed Waterloo as "Birthplace of Memorial Day." Soon after, the US Congress passed Resolution 587, declaring, "the Congress of the United States officially recognizes Waterloo, New York as the birthplace of Memorial Day."

President Lyndon B. Johnson signed the proclamation and then declared Memorial Day a federal holiday on May 30, 1966.

There is a wonderful museum, the National Memorial Day Museum, on Main Street in Waterloo (Rt. 20), which tells the history and the story of the village's successful attempt to be so recognized. There are exhibits, archival photographs, and documentation of the city's history of decorating the graves of veterans. The star of this museum is the actual pen used by President Johnson to sign the Memorial Day holiday legislation.

An interesting question: Who picked the day to celebrate Memorial Day? There is no definitive word on this, but scholars believe that the end of May provided the best window for an abundance of flowers to be available to decorate the graves.

The welcome sign at the village's entrances also mentions that it is the home of Tom Coughlin. He was born here on August 31, 1946. As head football coach of the New York Giants, he led his team to two Super Bowl wins in 2008 and 2012.

Website: https://wlhs-ny.com/national-memorial-day-museum/

49

WATERVILLE, ONEIDA COUNTY

"THE HISTORIC CENTER OF INTERNATIONAL HOPS COMMERCE"

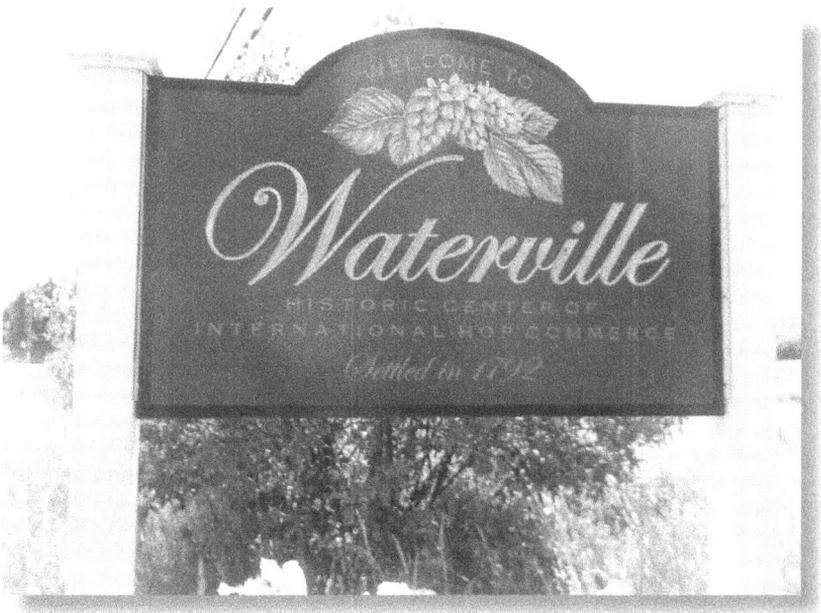

One of Upstate's most pleasant small towns (under 2,000 residents), its early history as a major hop distributor has left an imprint of small shops, fine Victorian-style homes, and well-planned neighborhoods streets.

111

Central New York was long known a premier hop growing center. The Cooperstown area of Otsego County comes to mind for most of us. But Waterville was the hub of the hop's wheel, geographically speaking. Hops were introduced here around 1820, and within fifty years Waterville was the hop center of the world. Hundreds of acres of farmland grew hops, many hop innovations (some still used) were created here, the International Hop Exchange was formed here in the 1880s, and major railroads established routes here to carry the Waterville Hops around the country and around the world.

A key development in the hop industry was the method of extracting from the hop blossom the ingredient that flavored beer. Because of this, hop farmers were able to "store" their liquid crop from lean year to boom year, which helped to stabilizes the hop market price. In the 1870s, the first industrial plant for the extraction of hop "flour" was built here, making it the first hop extract in the country.

To say that Waterville was a "hopping" place during this period would be true, a bad pun, yes, but also very true.

A true reflection of Waterville's glory years can be found in what is known as the Waterville Triangle Historic District. Made up of three intersecting streets in the business district, it is not hard to view the architecture and landscape layout to realize how profitable the hop business was to this small rural community.

Waterville is a delightful village to visit. It has many delicious places to dine, a walkable footprint, some graceful antique lampposts along the way, lots of flowers and gardens, some interesting small mom-and-pop retail stores, and many beautiful homes to view.

The most famous person to come out of Waterville was George Eastman, born there on July 12, 1854. He went on to found the Eastman Kodak Company and is known as "The Father of American Photography."

Waterville Historical Society at: https://watervillenyhistoricalsociety.wordpress.com/

50

WHITEHALL,
WASHINGTON COUNTY

"BIRTHPLACE OF THE U.S. NAVY"

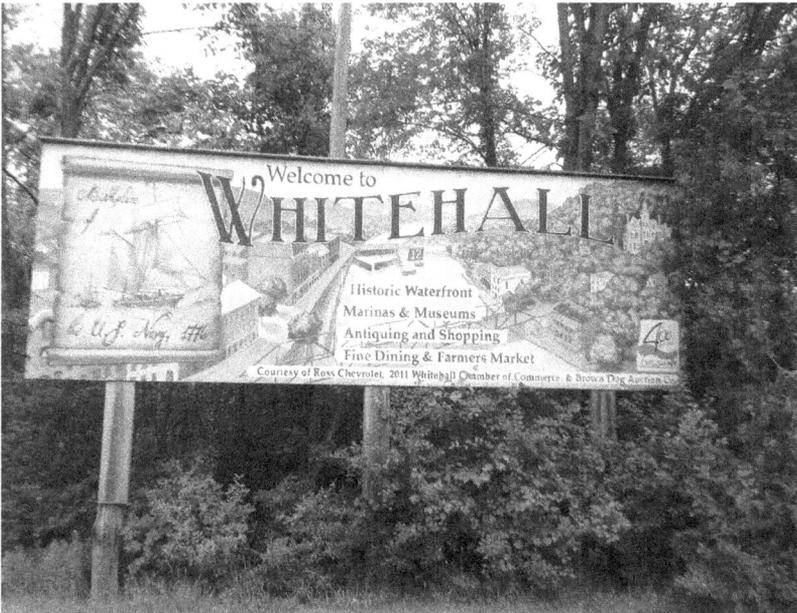

For a first-time visitor, this welcome sign must be a bit of a puzzler. "Birth-place of the U.S. Navy"? If that were a *Jeopardy* question, what would you say? Annapolis? Yes, I might say the same thing.

But it is here, in this small Washington County community of 4,000, where the title rests. At first glimpse, you might ask, "Where is the water?"

There is a small canal that runs through the village, but the real naval action that gave the title to Whitehall happened just a little bit further up on Lake Champlain.

In the late 1700s, this place was known as Skenesborough. In the Revolutionary War, it took on great importance as a harbor town on the lower end of Lake Champlain. The lake was fought over by the Americans and the British, as it was a vital gateway to both Canada and the south, where the Hudson River began its flow to the Atlantic. Brigadier General Benedict Arnold and his troops captured the village from the British in 1774. Under orders from General Philip Schuyler, Arnold built a small fleet of ships and was ordered to take his ships and 650 men and sail up the lake and engage the much larger British navy (1,750 men).

In what is now known as the Battle of Valcour Island, the battle was engaged on October 11, 1776. Although not a great naval success, the engagement was credited with stopping the British fleet's attempt to sail down the Hudson River. Arnold took the few ships that survived the battle back to Skenesborough, where he scuttled and burned them so as not to let them fall into British hands.

Eighty Americans were killed or wounded, and forty British sailors were killed or wounded in the short but fierce battle.

This event is marked as the first US naval battle and is the nexus for the town becoming known forever as the birthplace of the US Navy.

After the war, the name of the town was changed to Whitehall. There is a very interesting museum here that tells the story of the Battle of Valcour Island and the involvement of the locals in such an important historical event.

Skenesborough Museum (Whitehall): https://skenesborough.com/skenes borough-museum/

51

WYOMING, WYOMING COUNTY

"THE GASLIGHT VILLAGE"

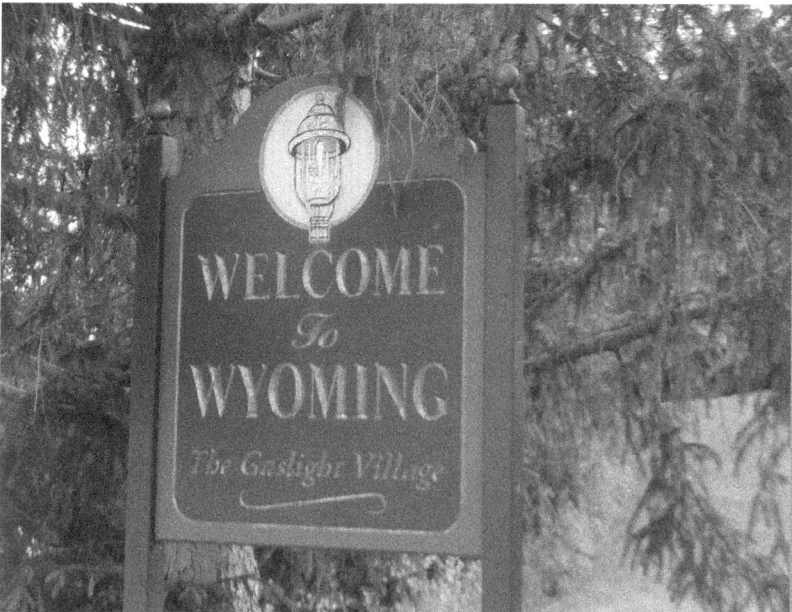

The sidewalks in the central part of this adorable village are dotted with natural gas lampposts. The effect is a charming "Disney-like" aura to Wyoming, known as "The Gaslight Village." The community sits over a natural gas pocket and in fact is one of the earliest-known places where natural gas was developed in the United States.

Over a century ago, the village struck a deal with a gas company, giving it distribution rights to the gas as long as the few hundred citizens of Wyoming could benefit from the product through the lighting of the streets and some homes with gas lamps.

The old cast-iron lampposts up and down the main boulevard of the village are ornate in a Victorian-era way. They give an unmistakable "old timey" feel to Wyoming that remains even today, decades later. The village is one of only a handful in the Northeast that has natural gas street lamps.

The village hosts one of the largest craft fairs in western New York each year. The AppleUmpkin Festival originated as a celebration of the apple and pumpkin harvest in this rich agricultural region. Today, thousands attend the craft festival, which features food, live entertainment and hundreds of vendor tents spread out all over town. The September festival has been going on for over thirty years.

AppleUmpkin Festival: www.appleumpkinfestival.com

INDEX

www.ingramcontent.com/pod-product-compliance
Lightning Source LLC
Chambersburg PA
CBHW060054100426
42742CB00014B/2819